The Best OF Business Card 4 Design

ROCKPORT

First published in the United States of America by

Rockport Publishers, Inc.
33 Commercial Street
Gloucester, Massachusetts 01930-5089
Telephone: (978) 282-9590
Facsimile: (978) 283-2742
www.rockpub.com

ISBN 1-56496-667-4

10 9 8 7 6 5 4 3 2 1

Design: Jeannet Leenderste

Cover Design: Mark van Bronkhorst

Thank you to Diane Jones for her upbeat approach and stamina, Cathy Kelley of Rockport Publishers for her gentle guidance, and Jay Donahue of Rockport Publishers for his persistence.

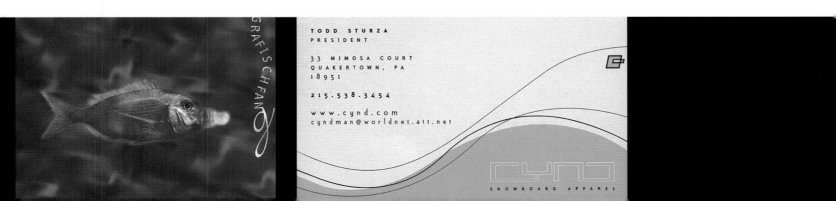

GRAFISCHFANG

TODD STURZA
PRESIDENT

33 MIMOSA COURT
QUAKERTOWN, PA
18951

215.538.3454

www.cynd.com
cyndman@worldnet.att.net

CYND
SNOWBOARD APPAREL

1

Design Firm
Atelier Tadeusz Piechura

Art Director
Tadeusz Piechura

Designer
Tadeusz Piechura

Client
Mariusz Wieczorek

Software/Hardware
Corel 7, Pentium 200

Printing
Offset, 2nd Edition, New Version

2

Design Firm
Manhattan Transfer

Art Director
Micha Riss

Designer
Patrick Asuncion

Client
Self-promotion

Software/Hardware
Adobe Illustrator, Macintosh

Paper/Materials
Plastic

Printing
Digicard

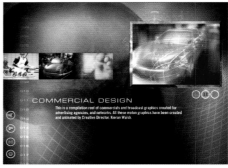

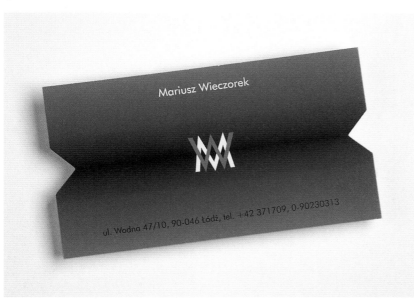

Introduction

In this day and age when most people are communicating digitally, it is becoming more and more important to actually exchange something tactile. Something you can put in your wallet; something you can hold on to.

Manhattan Transfer's answer to this is a self-promoting business card which is, in fact, a multimedia presentation. The digicard format allows us to meet the employees and see the company's portfolio. What a wonderful way to get a feel for their business!

Tadeusz Piechura designs business cards that are extremely conceptual, minimalist, and often sculptural. He produces tiny works of art you truly want to own. Boot's variety of self-promotional cards makes you want to collect them all.

One of the entry envelopes I opened (I think it came from Italy) had a card in it that carried the scent of a heady cologne. Even the highest resolution on screen or in print cannot replace the tactile quality of so many of the cards in this book. The exchange of business cards can be so very personal, and when you pick one up in a restaurant where the dining experience was just perfect, you take a piece of that time and that place with you. Therein lies the eternal allure of the business card.

The well-designed business card plays a variety of roles, all its own, and it speaks for itself!

—Jeannet Leendertse

3
Design Firm
 Studio Boot
Art Directors
 Petra Janssen, Edwin Vollebergh
Designers
 Petra Janssen, Edwin Vollebergh
Illustrator
 Studio Boot
Client
 Self-promotion
Paper/Materials
 MC on 3mm Grey Board
Printing
 Full Color and Laminate

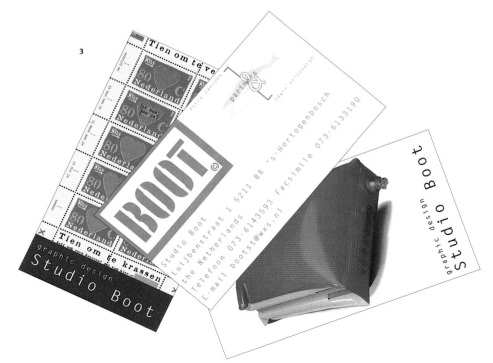

2
Design Firm
 The Riordon Design Group
Art Director
 Ric Riordon
Designer
 Dan Wheaton
Client
 Self-promotion
Software/Hardware
 Adobe Illustrator, Adobe
 Photoshop, QuarkXpress
Paper/Materials
 Beckett Expression
Printing
 Somerset Graphics

3
Design Firm
 Matite Giovanotte
Art Director
 Stefania Adani
Designer
 Stefania Adani
Client
 XT Societá Di Consulenza
Software/Hardware
 Freehand, Macintosh
Paper/Materials
 Fedrigoni Nettuno Bianco Artico
Printing
 2 Colors

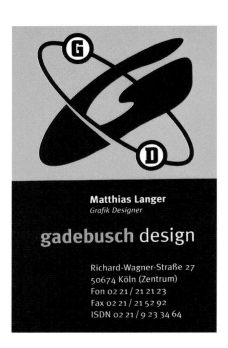

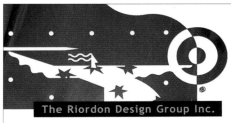

2

3

1
Design Firm
 Langer Design
Designer
 Matthias Langer
Client
 Gadebusch Design
Software/Hardware
 QuarkXpress, Freehand,
 Macintosh
Printing
 2 Colors

Design Firm
 The Riordon Design Group
Art Director
 Ric Riordon
Designer
 Dan Wheaton
Client
 Chuck Gammage Animation
Software/Hardware
 Adobe Photoshop, QuarkXpress
Paper/Materials
 Classic Crest
Printing
 Somerset Graphics

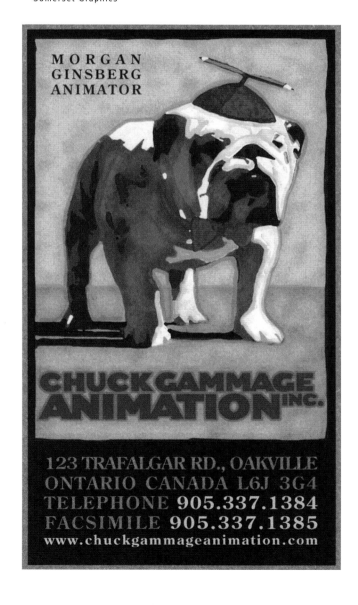

Design Firm
 Sibley Peteet Design
Art Director
 Donna Aldridge
Designer
 Donna Aldridge
Illustrator
 Donna Aldridge
Client
 Ray Laskowitz
Software/Hardware
 Adobe Illustrator, Macintosh
Paper/Materials
 Cougar Opaque Cream
Printing
 Millet The Printer

PIECEWORK
PRODUCTIONS

RAY LASKOWITZ
PHOTOGRAPHER
DALLAS, TEXAS
75214·0734

214·941·3678
PWork1121@AOL.com

1
Design Firm
 Creative Company
Art Director
 Chris Novd
Designer
 Chris Novd
Client
 Roth Heating & Cooling
Software/Hardware
 Macintosh
Paper/Materials
 Lustro Dull
Printing
 Panther Print

2
Design Firm
 Niehinger & Rohsiepe
Art Directors
 C. Niehinger, H. Rohsiepe
Designers
 C. Niehinger, H. Rohsiepe
Client
 Eckart Schuster, Consultant
Software/Hardware
 Freehand 8.0, Macintosh
Paper/ Materials
 Gmund Die Natuerlichen
Printing
 Black, Red, and Silver

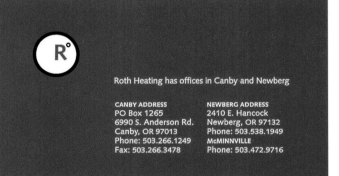

Derek Craven

CANBY ADDRESS
Phone: 503.266.1249
Fax: 503.266.3478

ROTH
HEATING & COOLING

Roth Heating has offices in Canby and Newberg

CANBY ADDRESS
PO Box 1265
6990 S. Anderson Rd.
Canby, OR 97013
Phone: 503.266.1249
Fax: 503.266.3478

NEWBERG ADDRESS
2410 E. Hancock
Newberg, OR 97132
Phone: 503.538.1949
McMINNVILLE
Phone: 503.472.9716

1

ES:Z²

● eckart schuster
coaching & service consulting

philadelphiastraße 146-150
47799 krefeld
telefon 0 21 51 · 6 90 47
telefax 0 21 51 · 2 94 37
mobil 01 72 · 2 07 90 17

2

Design Firm
 R & M Associati Grafici
Art Directors
 Di Somma/Fontanella
Client
 Self-promotion
Software/Hardware
 Adobe Illustrator, Macintosh
Printing
 Offset

wasps artists' studios
256 Alexandra Parade
Glasgow G31 3AJ
tel +44 141 554 2499
fax +44 141 556 5340
email gillianblack@waspsstudios.org.uk
web www.waspsstudios.org.uk

Gillian Black
General Manager

Design Firm
 Graven Images Ltd.
Art Director
 Janice Kirkpatrick
Designer
 Colin Raeburn
Client
 Wasps Artists' Studios
Software/Hardware
 Adobe Illustrator, QuarkXpress
Paper/Materials
 Conqueror, Oyster Wove, 300 gsm
Printing
 2 Color Litho

1

Design Firm
J. Gail Bean, Graphic Design

Art Director
J. Gail Bean

Designer
J. Gail Bean

Illustrator
J. Gail Bean

Client
Self-promotion

Software/Hardware
Adobe Illustrator 7.0, Macintosh

Paper/Materials
Cougar 80 lb. Natural Smooth

Printing
Rainbow Printing, Marietta GA;
2 Color

2

Design Firm
Dean Johnson Design

Art Director
Bruce Dean

Designer
Bruce Dean

Illustrator
Bruce Dean

Client
Tod Martens Photography

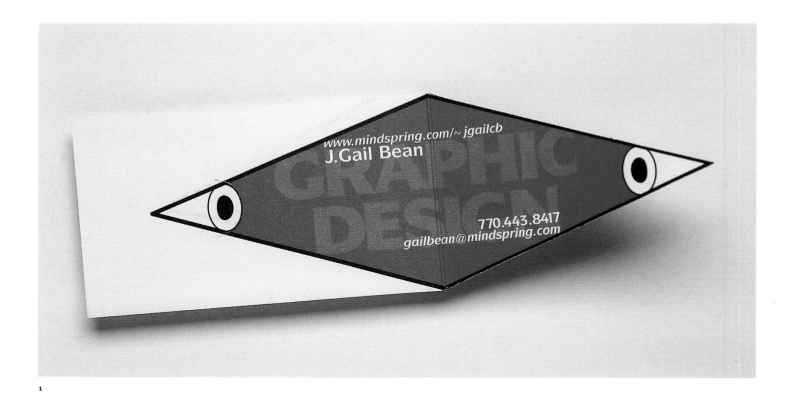

1

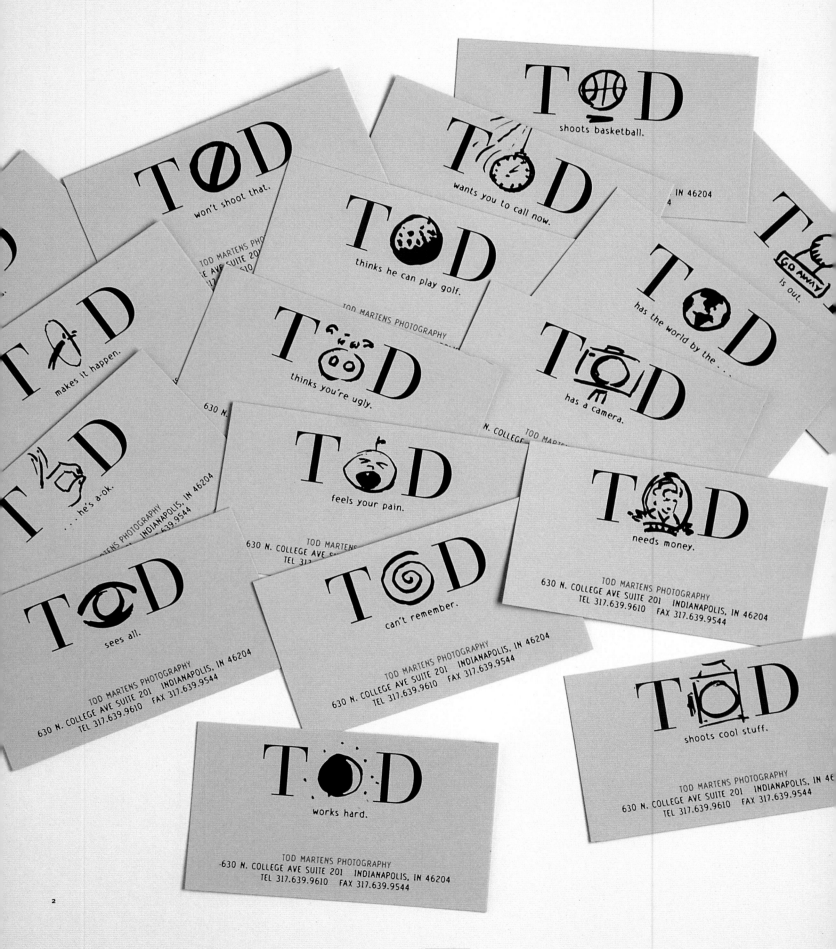

TOD shoots basketball.

TØD won't shoot that.

TOD wants you to call now.

TOD thinks he can play golf.

TOD has the world by the . . .

TOD is out. GO AWAY

T·D makes it happen.

TOD thinks you're ugly.

TOD has a camera.

TOD ...he's a·ok.

TOD feels your pain.

TOD needs money.

TOD sees all.

TOD can't remember.

TOD shoots cool stuff.

TOD works hard.

IN 46204

TOD MARTENS PHOTOGRAPHY

630 N. COLLEGE AVE SUITE 201 INDIANAPOLIS, IN 46204
TEL 317.639.9610 FAX 317.639.9544

TOD MARTENS PHOTOGRAPHY
630 N. COLLEGE AVE SUITE 201 INDIANAPOLIS, IN 46204
TEL 317.639.9610 FAX 317.639.9544

TOD MARTENS PHOTOGRAPHY
-630 N. COLLEGE AVE SUITE 201 INDIANAPOLIS, IN 46204
TEL 317.639.9610 FAX 317.639.9544

TOD MARTENS PHOTOGRAPHY
630 N. COLLEGE AVE SUITE 201 INDIANAPOLIS, IN 46

2

Ludolf-Krehl-Straße 13–17
68167 Mannheim
Telefon: (06 21) 33 89 4-0
Telefax: (06 21) 33 89 4-50
ISDN: (06 21) 33 89 4-15
http://www.gag-ma.de
EMail: info@gag-ma.de

gag ■ DESIGN

Gerhard.Fontagnier@gag-ma.de
DW 33 89 4-44
Bettina.Lindner@gag-ma.de
DW 33 89 4-55
Andrea.Schmalz@gag-ma.de
DW 33 89 4-88
Silke.Heck@gag-ma.de
DW 33 89 4-66
Natalia.Fontagnier@gag-ma.de
DW 33 89 4-10

1

Gerhard Fontagnier | Grafik-Design

bei gag : grafische ateliergemeinschaft

Ludolf-Krehl-Straße 13–17

68167 Mannheim

Telefon 06213389444 · Telefax 06213389450

E-Mail: gerhard.fontagnier@gag-ma.de

TeLMi 0166-1-8016272 Textnachrichten
0166-5-8016272 Sprachbox

© telmi-gag-card 0130-167699

2

mörlbacher weg 1
82335 berg
fon: 08151 953865
fax: 08151 953863
mobil: 0171 6070067
email: peterruehmann@livelife.de
http://www.livelife.de

Peter Rühmann

1
Design Firm
 gag
Art Director
 Gerhard Fontagnier
Designers
 Gerhard Fontagnier,
 Bettina Lindner,
 Ella Raikenheimer
Client
 Self-promotion
Software/Hardware
 Freehand, Adobe Photoshop,
 Macintosh
Paper/Materials
 276 g
Printing
 Offset 4/7 Lack

2
Design Firm
 gag
Art Director
 Gerhard Fontagnier
Designers
 Gerhard Fontagnier,
 Bettina Lindner,
 Ella Raikenheimer
Client
 Gerhard Fontagnier
 Grafik-Design
Software/Hardware
 Freehand, Adobe Photoshop,
 Macintosh
Paper/Materials
 276 g
Printing
 Offset 4/7 Lack

3
Design Firm
 gag
Art Director
 Gerhard Fontagnier
Designers
 Gerhard Fontagnier,
 Bettina Lindner,
 Ella Raikenheimer
Client
 Peter Rühmann
Software/Hardware
 Freehand, Adobe Photoshop,
 Macintosh
Paper/Materials
 276 g
Printing
 Offset 4/7 Lack

4
Design Firm
 gag
Art Director
 Gerhard Fontagnier
Designers
 Gerhard Fontagnier,
 Bettina Lindner,
 Ella Raikenheimer
Client
 Peter Loos
Software/Hardware
 Freehand, Adobe Photoshop,
 Macintosh
Paper/Materials
 276 g
Printing
 Offset 4/7 Lack

4

Design Firm
 Treehouse Design
Art Director
 Tricia Rauen
Designer
 Tricia Rauen
Client
 Salon Blu
Software/Hardware
 Adobe Illustrator
Paper/Materials
 Strathmore Elements
Printing
 Blair Graphics

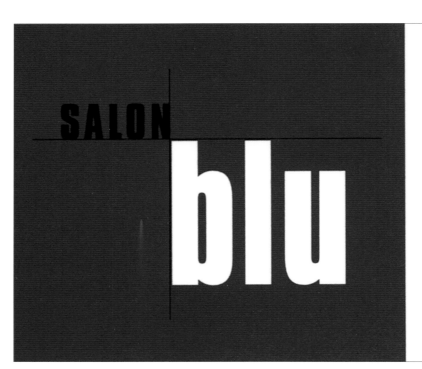

SALON

blu

Dino Gugliuzza

2510 Main Street
Suite D
Santa Monica
California 90405

310.392.3331 *tel*
310.392.4811 *fax*

1

ULRIKE WALZ

PERFORMA
MÖBELBAU +
PLANUNG

MARBACHER STR.16
71686 REMSECK
TEL. 07146 / 32 61
FAX 07146 / 63 65

PERFORMA

2

1
Design Firm
Langer Design
Designer
Matthias Langer
Client
Thorsten Pohl, Cutter & Editor
Software/Hardware
QuarkXpress, Adobe Photoshop,
Macintosh
Printing
2 Colors

2
Design Firm
Michael Kimmerle·Art
Direction + Design
Art Director
Michael Kimmerle
Designer
Michael Kimmerle
Illustrator
Michael Kimmerle
Client
Performa
Software/Hardware
QuarkXpress, Macintosh
Paper/Materials
Naturals, König 650 glm2
Printing
Siebdruck, Screen Printing

3
Design Firm
Castenfors & Co.
Art Director
Jonas Castenfors
Designer
Jonas Castenfors
Client
Inredningsbyrån Inte & Co.
Software/Hardware
QuarkXpress
Paper/Materials
Skandia
Printing
Elfströms Tryckeri

inredningsbyrån INTE & CO

ROBERT ÖHMAN

kommendörsgatan 12
114 48 stockholm
telefon 08-407 06 01
telefax 08-678 33 44
mobil 070-715 70 82
robert@inte-co.com
www.inte-co.com

3

Design Firm
Design Center
Art Director
John Reger
Designer
Sherwin Schwartzrock
Client
Streeter & Associates
Software/Hardware
Freehand, Macintosh
Paper/Materials
Strathmore Writing
Printing
Pro-Craft Printing

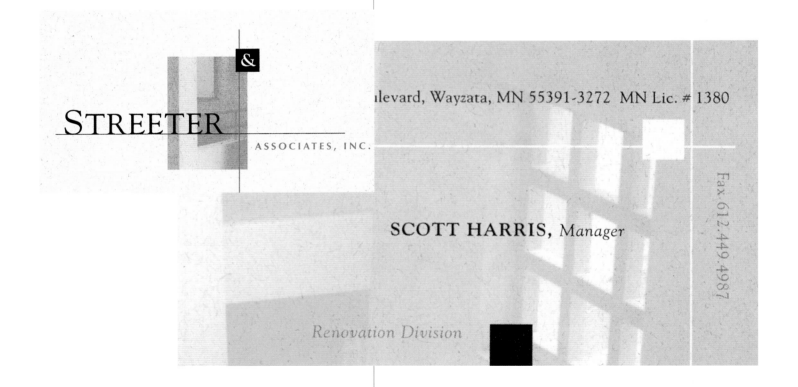

STREETER & ASSOCIATES, INC.

ilevard, Wayzata, MN 55391-3272 MN Lic. # 1380

SCOTT HARRIS, Manager

Fax 612.449.4987

Renovation Division

EMAIL lamarhamilton@compuserve.com

8400 NORMANDALE BOULEVARD
STE 920 BLOOMINGTON MN 55437

612

PHO 829.0651
FAX 829.0712

CoreVISION

MISSION: TO STRENGTHEN BUSINESS LEADERS THROUGH PERSONAL ADVISOR RELATIONSHIPS DESIGNED TO ENHANCE THE LEADER'S IMPACT, INTEGRATE WISDOM INTO DECISION-MAKING AND ACHIEVE PERSONAL FULFILLMENT.

Lamar Hamilton

1

Stickney Murphy Romine • Architects PLLC

911 Western Avenue
Suite 200
Seattle, Washington
98104
P: 206-623-1104
F: 206-623-5285

Michael W. Romine
Architect, AIA
Principal
mromine@smrarchitects.com

2

1
Design Firm
 Design Center
Art Director
 John Reger
Designer
 Scherwin Schwartzrock
Client
 Core Vision
Software/Hardware
 Freehand, Macintosh
Paper/Materials
 Strathmore Writing
Printing
 Print-Craft Printing

2
Design Firm
 Nichols & Zwiebel
Art Director
 Sharon Nichols
Designer
 Sharon Nichols
Client
 Stickney Murphy Romine
 Architects PLLC
Software/Hardware
 Adobe Photoshop, Freehand,
 Macintosh
Paper/Materials
 Strathmore Writing Cover 88 lb.
Printing
 PMS 193, Black

704 4038 FAX 704 0651

NEW YORK NY 10018 PHONE 212 704 4038 FAX 704 0651

2

1

Design Firm
Sagmeister Inc.
Art Director
Stefan Sagmeister
Designer
Hjalti Karlsson
Client
Anni Kuan
Software/Hardware
Adobe Illustrator, Macintosh
Paper/Materials
Strathmore Writing
Printing
Offset, laser die cut

2

Design Firm
Atelier Tadeusz Piechura
Art Director
Tadeusz Piechura
Designer
Tadeusz Piechura
Client
Mariusz Wieczorek
Software/Hardware
Corel 7, Pentium 200
Printing
Offset, 2nd Edition, New Version

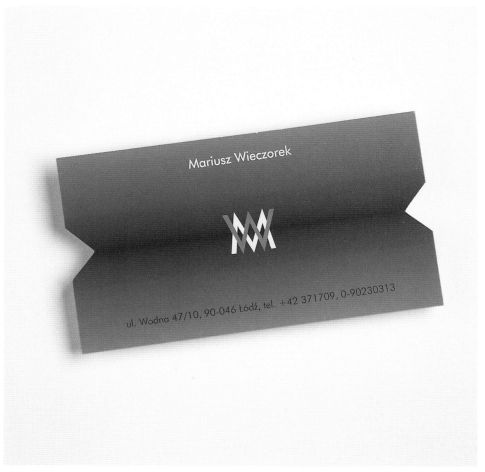

2

1
Design Firm
R & M Associati Grafici
Art Directors
Di Somma/Fontanella
Client
Paola Ocone
Software/Hardware
Adobe Illustrator, Macintosh
Printing
Offset

2
Design Firm
Design Center
Art Director
John Reger
Designer
Sherwin Schwartzrock
Client
Self-promotion
Software/Hardware
Freehand, Macintosh
Paper/Materials
Lustro Gloss
Printing
Pro-Craft Printing

PAOLA OCONE

VIA VARANO 72

80054 GRAGNANO (NA)

TELEFONO 081. 8712322

1

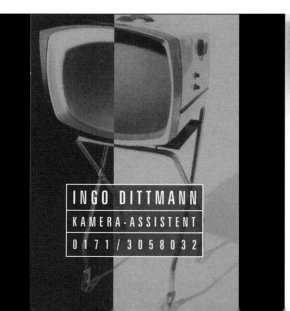
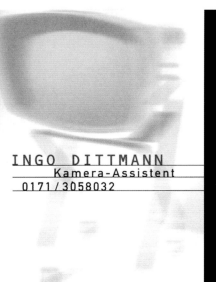
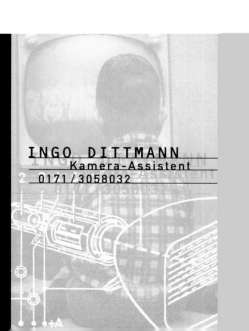

2

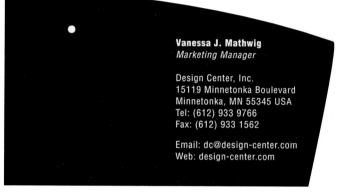

Vanessa J. Mathwig
Marketing Manager

Design Center, Inc.
15119 Minnetonka Boulevard
Minnetonka, MN 55345 USA
Tel: (612) 933 9766
Fax: (612) 933 1562

Email: dc@design-center.com
Web: design-center.com

INGO DITTMANN • KAMERA-ASSISTENT • 0171/3058032

3
Design Firm
 Langer Design
Designer
 Matthias Langer
Client
 Ingo Dittmann,
 Camera Assistant
Software/Hardware
 QuarkXpress, Adobe Photoshop,
 Macintosh
Printing

1
Design Firm
 Opera Grafisch Ontwerpers
Art Directors
 Ton Homburg, Marty Schoutsen
Designers
 Sappho Panhuysen,
 Ton Homburg
Client
 Rijksmuseum Voor Volkenkunde
Software/Hardware
 QuarkXpress, Macintosh
Paper/Materials
 Chambord
Printing
 Drukkerij Oomen Breda

2
Design Firm
 Case
Designer
 Kees Wagenaars
Client
 Self-promotion
Software/Hardware
 QuarkXpress
Paper/Materials
 Pecunia
Printing
 PMS 392

RIJKSMUSEUM voor
VOLKENKUNDE
LEIDEN National Museum
of Ethnology

Steenstraat 1
Postbus 212
2300 AE Leiden
The Netherlands

drs. Herman de Boer
head of exhibitions

T +31 (0)71 5168 800
F +31 (0)71 5128 437
herman@rmv.nl

1

case

Kees Wagenaars

Baronielaan 78 4818 RC Breda
t 076 5215187 f 076 5217457
e kwcase@knoware.nl

2

Design Firm
 Design Center
Art Director
 John Reger
Designer
 Cory Docken
Client
 Ncell Systems
Software/Hardware
 Freehand, Macintosh
Paper/Materials
 Strathmore Writing
Printing
 Pro-Craft

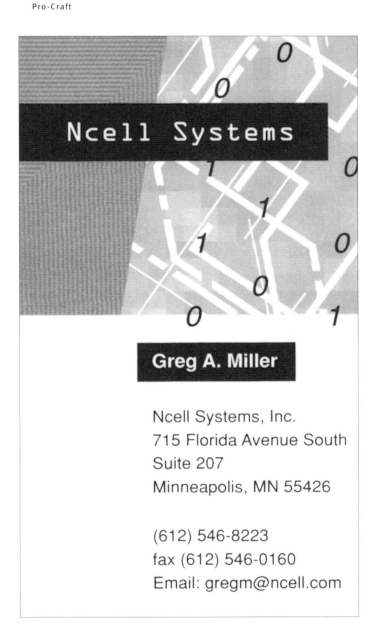

Ncell Systems

Greg A. Miller

Ncell Systems, Inc.
715 Florida Avenue South
Suite 207
Minneapolis, MN 55426

(612) 546-8223
fax (612) 546-0160
Email: gregm@ncell.com

1

BileniaTech

Noah Prywes
CEO. CCCC - General Partner

BileniaTech, LP
2400 Chestnut Street
Philadelphia. PA
19103-4316

Voice 215.854.0555
ext. 211
Fax 215.854.0665
Prywes@BileniaTech.com
www.BileniaTech.com

1

2

billennium
Year 2000 COBOL Software Factory

2300 chestnut street
philadelphia pa
19103

voice 215.854.0555
fax 215.854.0665
newshel@billenn.com
http://www.billenn.com

billennium.lp
tony newshel
general manager

2

1

Design Firm
LF Banks + Associates

Art Director
Lori F. Banks

Designer
John German

Client
BileniaTech, LP

Software/Hardware
Freehand

Paper/Materials
Neenah Classic Columns

Printing
RoyerComm Corporation

2

Design Firm
LF Banks + Associates

Art Director
Lori F. Banks

Designer
John German

Client
Billennium, LP

Software/Hardware
Freehand

Paper/Materials
Neenah Classic Columns

Printing
Fern Hill Printing Co.

3

Design Firm
LF Banks + Associates

Art Director
Lori F. Banks

Designer
John German

Client
@Risk, Inc.

Software/Hardware
Freehand, Adobe Photoshop

Paper/Materials
Neenah Classic Columns

Printing
Quality Lithographing Co.

Patrick M. Baldasare
President & CEO

@RISK
SolutionsThroughDataMining

web www.atRiskInc.com e-mail PBaldasare@atRiskInc.com
Tel 610.296.0800 x701 Fax 610.296.8181
1205 Westlakes Drive Suite 180 • Berwyn • PA • 19312

SolutionsThroughDataMining

3

Design Firm
 LF Banks + Associates
Art Director
 Lori F. Banks
Designer
 Lori F. Banks
Client
 Self-promotion
Software/Hardware
 Freehand
Paper/Materials
 Grafika Lineal
Printing
 Quality Lithographing Co.

lori banks
president

graphic design

web design

advertising

voice 215.627.2855
fax 215.627.6724
banks@lfbanks.com
http://www.lfbanks.com

834 Chestnut Street Suite 425 Philadelphia PA 19107

LFB design

L F Banks + **A**ssociates

1
Design Firm
 Cincodemayo Design
Art Director
 Mauricio H. Alanis
Designer
 Mauricio H. Alanis
Client
 Self-promotion
Software/Hardware
 Freehand 7.0, Macintosh
Paper/Materials
 Magnomatt
Printing
 5DM Offset Printing

1

LAURIE OKAMURA
QUEEN BEE

THE HIVE DESIGN STUDIO
10 JACKSON STREET, SUITE 204
LOS GATOS, CALIFORNIA 95032
PHONE 408.354.2961
FAX 408.354.3682
EMAIL: ELCY@AOL.COM

2

2
Design Firm
The Hive Design Studio
Art Directors
Laurie Okamura, Amy Stocklein
Designers
Laurie Okamura, Amy Stocklein
Client
Self-promotion
Software/Hardware
Adobe Illustrator, Macintosh
Paper/Materials
Cranes Crest
Printing
Mission Printers

Call Holm
More Often.

604 874-7200

Craig Holm.
Copywriter
Strategist
Idea Guy

¶

e-mail cholm@direct.ca

Call Me.
I'm Holm.

604 874-7200

Craig Holm.
Copywriter
Strategist
Idea Guy

¶

e-mail cholm@direct.ca

3
Design Firm
Big Eye Creative
Art Directors
Perry Chua, Dann Ilicic
Designer
Perry Chua
Copy writer
Craig Holm
Client
Craig Holm
Software/Hardware
Adobe Illustrator
Paper/Materials
Potlatch McCoy
Printing
Clarke Printing

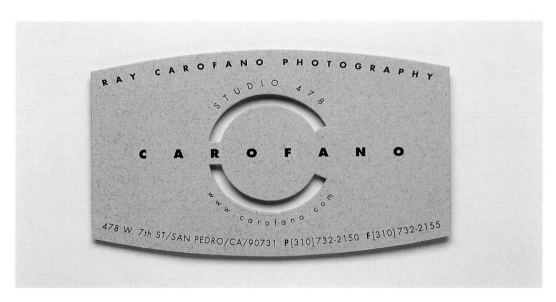

Design Firm
 D Zone Studio, Inc.
Designer
 Joe L. Yule
Client
 Ray Carofano Photography
Software/Hardware
 Adobe Illustrator, QuarkXPress
Paper/Materials
 Fraser Passport Cover
Printing
 1/0 Black

Design Firm
 Elizabeth Resnick Design
Art Director
 Elizabeth Resnick
Designer
 Elizabeth Resnick
Client
 Design Times Magazine
Software/Hardware
 QuarkXpress 3.32, Macintosh
Paper/Materials
 Mohawk Superfine Natural
Printing
 Alpha Press, Waltham, MA

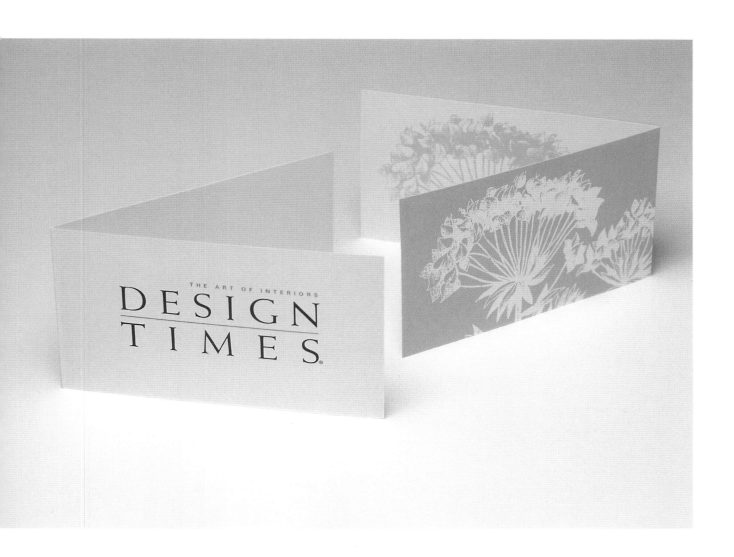

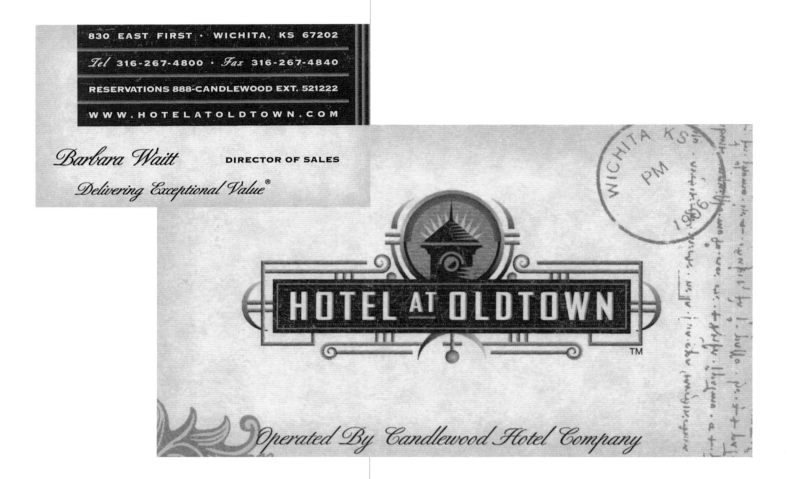

830 EAST FIRST · WICHITA, KS 67202

Tel 316-267-4800 · *Fax* 316-267-4840

RESERVATIONS 888-CANDLEWOOD EXT. 521222

W W W . H O T E L A T O L D T O W N . C O M

Barbara Waitt DIRECTOR OF SALES

Delivering Exceptional Value®

HOTEL AT OLDTOWN™

Operated By Candlewood Hotel Company

Design Firm
 Greteman Group
Art Director
 Sonia Greteman
Designers
 James Strange, Garrett Fresh
Client
 Hotel at Oldtown
Software/Hardware
 Freehand
Paper/Materials
 Astroparche Cream
Printing
 Offset

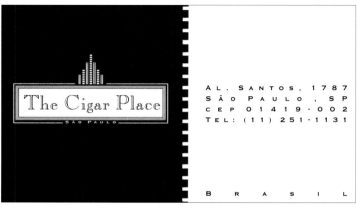

804.329.0661

C. BENJAMIN DACUS

bendacus@richmond.infi.net

1

The CONTINENTAL

DAVID RICCARDI

8400 WILSHIRE BLVD.

BEVERLY HILLS, CA 90211

323.782.9717

2

The Cigar Place

SÃO PAULO

AL. SANTOS, 1787
SÃO PAULO, SP
CEP 01419-002
TEL: (11) 251-1131

BRASIL

3

1
Design Firm
 Zeigler Associates
Art Director
 C. Benjamin Dacus
Designer
 C. Benjamin Dacus
Client
 C. Benjamin Dacus
Software/Hardware
 QuarkXpress
Paper/Materials
 French Construction
Printing
 Offset, Pine Tree Press,
 Richmond, VA

2
Design Firm
 [i]e design
Art Director
 Marcie Carson
Designers
 Cya Nelson, David Gilmour
Client
 The Continental
Software/Hardware
 Adobe Illustrator, Macintosh
Paper/Materials
 French Construction
Printing
 3 Metallic PMS

3
Design Firm
 José J. Dias da S. Junior
Art Director
 José J. Dias da S. Junior
Designer
 José J. Dias da S. Junior
Client
 The Cigar Place
Software/Hardware
 Corel Draw, PC
Paper/Materials
 Unpolished Couche 180 g
Printing
 2 Color (Black & Pantone 1385)

DE ZONNEHOF
centrum voor moderne kunst

Zonnehof 4a • Postbus 699 • 3800 AR Amersfoort
T 033 4633034 **F** 033 4652691
E zonnehof@worldonline.nl

DE ZONNEHOF
centrum voor moderne kunst

TINNEKE SCHOLTEN
medewerker artotheek

Zonnehof 4a • Postbus 699 • 3800 AR Amersfoort
T 033 4633034 **F** 033 4652691
E zonnehof@worldonline.nl

Design Firm
Opera Grafisch Ontwerpers
Art Directors
Ton Homburg, Marty Schoutsen
Designer
Marty Schoutsen
Client
De Zonnehof
Software/Hardware
QuarkXpress, Macintosh
Paper/Materials
Oxford 250 gr.
Printing
Drukkerŷ Printing

1
Design Firm
Vestígio
Art Director
Emanuel Barbosa
Designer
Emanuel Barbosa
Client
Emanuel Barbosa Design
Software/Hardware
Freehand, Macintosh
Paper/Materials
Torras Paper

2
Design Firm
The Weller Institute for the
Cure of Design, Inc.
Art Director
Don Weller
Designer
Don Weller
Illustrator
Don Weller
Client
Park City Museum
Software/Hardware
Photoshop, QuarkXpress

b

**Emanuel
Barbosa
Design**

Rua da Vassada, 1682
Milheirós
4470 Maia
Tel. 02 - 9011868
Portugal

PARK CITY MUSEUM

Marianne Cone
Director

528 Main St.
P.O. Box 555
Park City, UT 84060
(801)649-0375

1

2

Alexander Stone & Co.
solicitors

Anita K Salwan

4 west regent street, glasgow G2 1AW
tel: +44 (0) 141 332 8611
fax: +44 (0) 141 332 5482
e-mail: mailbox@alexanderstone.co.uk

1

Heads Inc.
176 Thompson Street #2D New York, NY 10012
T+F 212 533 8693

So Takahashi

PMS 5743

2

1
Design Firm
 Graven Images Ltd.
Art Director
 Mandy Nolan
Designer
 Colin Raeburn
Client
 Alexander Stone & Co. Solicitors
Software/Hardware
 QuarkXpress. Macintosh
Paper/Materials
 Conqueror, Brilliant White, 300 gsm
Printing
 3 Color Litho

2
Design Firm
 Heads Inc.
Art Director
 So Takahashi
Designer
 So Takahashi
Client
 Self-promotion
Software/Hardware
 QuarkXpress
Printing
 GM Imaging

Design Firm
 400 Communications Ltd.
Art Director
 Peter Dawson
Designer
 Peter Dawson
Client
 Print & Design Limited
Software/Hardware
 QuarkXpress, Macintosh
Printing
 2 Color Litho

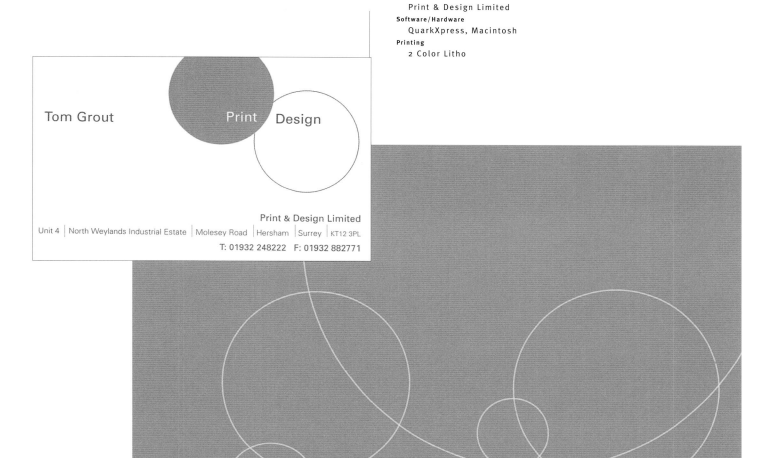

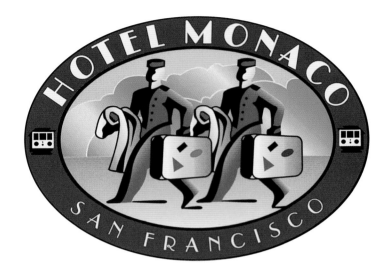

1

MATTHEW JENSEN
DIRECTOR OF SALES

501 GEARY STREET
SAN FRANCISCO, CALIFORNIA 94102
DIRECT 415-292-8131 / 800-214-4220
FAX: 415-292-0149
AIRLINE ACCESS CODE: KC

OTHER KIMPTON GROUP
HOTELS:

SAN FRANCISCO • THE PRESCOTT HOTEL 800-283-7322 • SEATTLE • HOTEL VINTAGE PARK 800-624-4433 • PORTLAND • HOTEL VINTAGE PLAZA 800-243-0555 • BEVERLY HILLS • BEVERLY PRESCOTT HOTEL 800-421-3212 • SEATTLE • ALEXIS HOTEL 800-426-7033 •

1
Design Firm
 Second Floor
Art Director
 Warren Welter
Designer
 Lori Powell
Illustrator
 Lori Powell
Client
 Hotel Monaco/Kimpton Group
Software/Hardware
 QuarkXpress, Adobe
 Illustrator, iMac
Printing
 Hatcher Press

2
Design Firm
 Wallace/Church
Art Director
 Stan Church
Designer
 Wendy Church
Illustrator
 Lucian Toma
Client
 The Axis Group, Llc.
Software/Hardware
 Adobe Photoshop,
 Adobe Illustrator

3
Design Firm
 Bruce Yelaska Design
Art Director
 Bruce Yelaska
Designer
 Bruce Yelaska
Client
 Self-promotion
Software/Hardware
 Adobe Illustrator
Paper/Materials
 Strathmore Writing Wove
Printing
 Offset - Vision Printing

4
Design Firm
 Inox Design
Art Director
 Mauro Pastore
Designer
 Mauro Pastore
Client
 Free Pass
Software/Hardware
 Adobe Photoshop,
 QuarkXpress,
 Adobe Illustrator
Printing
 Offset, 2 Colors

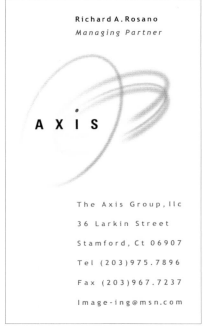

Richard A. Rosano
Managing Partner

A X I S

The Axis Group, llc

36 Larkin Street

Stamford, Ct 06907

Tel (203)975.7896

Fax (203)967.7237

Image-ing@msn.com

2

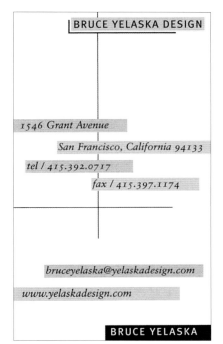

BRUCE YELASKA DESIGN

1546 Grant Avenue

San Francisco, California 94133

tel / 415.392.0717

fax / 415.397.1174

bruceyelaska@yelaskadesign.com

www.yelaskadesign.com

BRUCE YELASKA

3

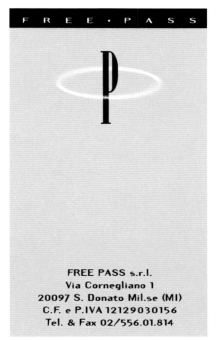

FREE • PASS

FREE PASS s.r.l.
Via Cornegliano 1
20097 S. Donato Mil.se (MI)
C.F. e P.IVA 12129030156
Tel. & Fax 02/556.01.814

4

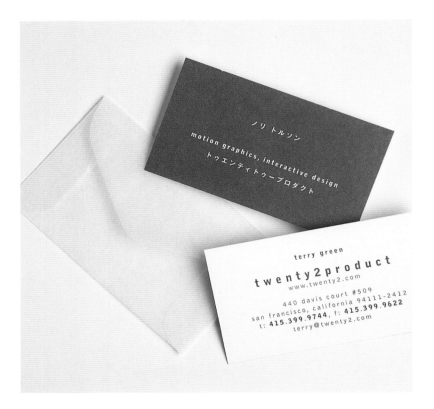

Design Firm
twenty2product
Art Director
Terry Green
Designer
Terry Green
Client
Self-promotion
Software/Hardware
Freehand
Paper/Materials
Simpson Protocol,
Westvaco Glassine
Printing
Valencia Printing

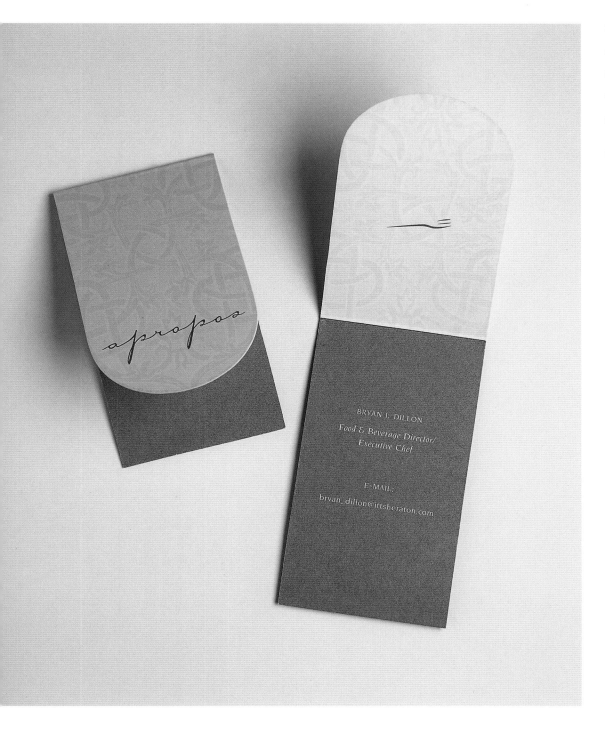

Design Firm
 Harris Design
Art Director
 Toni Harris-Hadad
Designer
 Toni Hadad
Client
 Apropos
Software/Hardware
 QuarkXpress, Adobe Photoshop,
 Adobe Illustrator 8
Printing
 Offset, 2 PMS, die cut

Rick Vermeulen

Via Vermeulen
William Boothlaan 4
3012 VJ Rotterdam
The Netherlands
Tel: + 31 (0)10 - 213.27.80
Fax: + 31 (0)10 - 213.47.22
e-mail: viarick@ipr.nl

1

perdura
Stahl- und Anlagentechnik Michael Rammelmann

Dipl.-Ing. Michael Rammelmann
Geschäftsführer

Industriestraße 7
D-59457 Werl
Tel. 0 29 22 • 86 51 86
Fax 0 29 22 • 86 51 88
mobil 01 73 • 2 72 89 32
e-mail perdura-werl@t-online.de

2

1
Design Firm
 Via Vermeulen
Art Director
 Rick Vermeulen
Designer
 Rick Vermeulen
Photographer
 Monica Nouwens
Client
 Self-promotion

2
Design Firm
 graphische formgebung
Art Director
 Herbert Rohsiepe
Designer
 Herbert Rohsiepe
Client
 Perdura
Software/Hardware
 Freehand 8.0, Macintosh
Printing
 Blue, Black, & Silver

83 COLUMBIA ST. SUITE 400, SEATTLE, WA 98104

TEL 206·682·3685 FAX 206·682·3867

HAMMERQUIST & HALVERSON

CAROL DAVIDSON

E-MAIL carol@hammerquist.net

Design Firm
 Hornall Anderson Design Works
Art Director
 Jack Anderson
Designers
 Jack Anderson, Mike Calkins
Illustrator
 Mike Calkins
Client
 Hammerquist & Halverson
Software/Hardware
 Freehand, Macintosh
Paper/Materials
 Mohawk Navaho

spoken digitized written spoken

digitized spoken digitized writt

en digitized written spoken

tized written spoken digitiz

ten spoken digiti

en digitized writt

ROBIN SHEPHERD
creative communications

18576 TWIN CREEKS ROAD
MONTE SERENO, CA 95030
PHONE: 408.354.2441
FAX: 408.354.3181
EMAIL: rswriter@flash.net
WEB: www.greatwords.com

WORDS WITH IMPACT

Design Firm
 The Hive Design Studio
Art Directors
 Laurie Okamura, Amy Stocklein
Designers
 Laurie Okamura, Amy Stocklein
Illustrator
 Pete Caravalho
Client
 Robin Shepherd
Software/Hardware
 Adobe Illustrator, Macintosh
Paper/Materials
 Strathmore
Printing
 Mission Printers

Design Firm
Big Eye Creative
Art Director
Perry Chua
Designers
Perry Chua, Nancy Yeasting
Client
Clarke Printing
Software/Hardware
Adobe Illustrator
Paper/Materials
Starwhite Vicksburg
Printing
Clarke Printing

sean clarke

C L A R K E P R I N T I N G

105-366 east kent avenue s.
vancouver bc v5x 4n6
tel **604** 327.2213 fax 327.2240

changing the way you think about printing.

sean clarke

C L A R K E P R I N T I N G

105-366 east kent avenue s.
vancouver bc v5x 4n6
tel **604** 327.2213 fax 327.2240

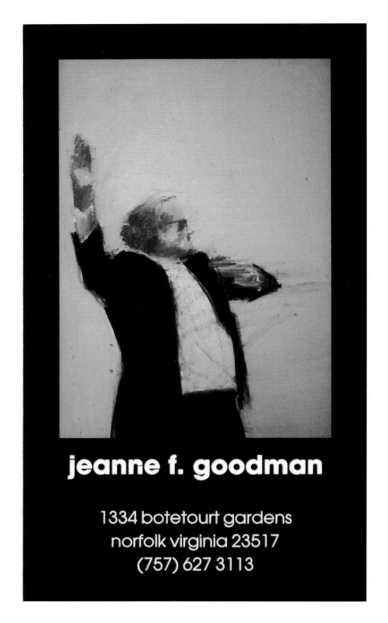

jeanne f. goodman

1334 botetourt gardens
norfolk virginia 23517
(757) 627 3113

Design Firm
Jeanne Goodman
Art Director
Jeanne Goodman
Designer
Jeanne Goodman
Illustrator
Jeanne Goodman
Client
Self-promotion

Stefan Delaeter
Promotiemanager

Hendrik Kiekens
Account Executive Radio

Paul Driesen
Coördinator Radio & TV, VAR-VRT

Francis Tilborghs
Manager Marketing Information Systems

Vlaamse Audiovisuele Regie

Willy Van Poucke
Product Manager Publishing

Vlaamse Audiovisuele Regie
Tollaan 107b bus 3 · B-1932 Sint-Stevens-Woluwe
Tel. +32 (0) 2 716 34 51 · Fax +32 (0) 2 725 39 77
e-mail: willy.van.poucke@var.be

Design Firm
Desgrippes Gobé Brussels
Art Director
Brigitte Evrard
Designer
Joane Claisse
Photographer
Royalty Free Images
Client
VAR
Software/Hardware
Adobe Photoshop
Paper/Materials

1
Design Firm
 H3/Muse
Designer
 Harry M. Forehand III
Client
 Jeff Forehand
Software/Hardware
 Macintosh
Printing
 Local Color, Santa Fe

2
Design Firm
 H3/Muse
Designer
 Harry M. Forehand III
Client
 Orotund Turmoil
Software/Hardware
 Macintosh
Printing
 Local Color, Santa Fe

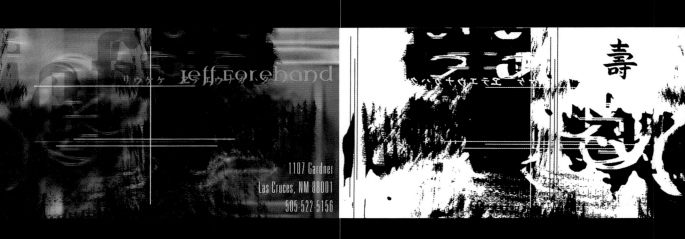

Design Firm
H3/Muse
Designer
Harry M. Forehand III
Client
Tim Forehand
Software/Hardware
Macintosh
Printing
Local Color, Santa Fe

Design Firm
 Atelier Tadeusz Piechura
Art Director
 Tadeusz Piechura
Designer
 Tadeusz Piechura
Client
 TVP - LODZ
Software/Hardware
 Corel 7, Pentium 200
Printing
 Offset

Design Firm
Atelier Tadeusz Piechura
Art Director
Tadeusz Piechura
Designer
Tadeusz Piechura
Client
Photo Studio,
Jacek Jakub Marczewski
Software/Hardware
Corel 7, Pentium
Printing
Laser Printer, 2nd Edition,
New Version

1
Design Firm
 gag
Art Director
 Gerhard Fontagnier
Designers
 Gerhard Fontagnier,
 Bettina Lindner,
 Ella Raikenheimer
Client
 Dr. Henning Madsen
 Kieferorthopäde
Software/Hardware
 Freehand, Adobe Photoshop,
 Macintosh
Paper/Materials
 276 g
Printing
 Offset 4/7 Lack

2
Design Firm
 gag
Art Director
 Gerhard Fontagnier
Designers
 Gerhard Fontagnier,
 Bettina Lindner,
 Ella Raikenheimer
Client
 Self-promotion
Software/Hardware
 Freehand, Adobe Photoshop,
 Macintosh
Paper/Materials
 276 g
Printing
 Offset 4/7 Lack

Dr. Henning Madsen
Kieferorthopäde

PRAXIS
Ludwigstraße 36
67059 Ludwigshafen
Telefon 0621-591680
Fax 0621-5916820
http://www.madsen.de
email info@madsen.de

PRIVAT
Stephanienufer 19
68163 Mannheim
Telefon 0621-827444

1

GAG: GRAFISCHE ATELIERGEMEINSCHAFT

LUDOLF-KREHL-STRASSE 13–17 · 68167 MANNHEIM
TELEFON 0621-338940 · TELEFAX 0621-3389433
ISDN-DATEN: 0621-3389410
WWW.GAG-MA.DE · E-MAIL: INFO@GAG-MA.DE

2

1
Design Firm
 gag
Art Director
 Gerhard Fontagnier
Designers
 Gerhard Fontagnier,
 Bettina Lindner,
 Ella Raikenheimer
Client
 Kultur Rhein-Neckar e.V.
Software/Hardware
 Freehand, Adobe Photoshop,
 Macintosh
Paper/Materials
 276 g
Printing
 Offset 4/7 Lack

2
Design Firm
 gag
Art Director
 Gerhard Fontagnier
Designers
 Gerhard Fontagnier,
 Bettina Lindner,
 Ella Raikenheimer
Client
 Mr. Flo Gelius
Software/Hardware
 Freehand, Adobe Photoshop,
 Macintosh
Paper/Materials
 276 g
Printing
 Offset 4/7 Lack

3
Design Firm
 gag
Art Director
 Gerhard Fontagnier
Designers
 Gerhard Fontagnier,
 Bettina Lindner,
 Ella Raikenheimer
Client
 Contigo Gmblt
Software/Hardware
 Freehand, Adobe Photoshop.
 Macintosh
Paper/Materials
 276 g
Printing
 Offset 4/7 Lack

2

3

1

Design Firm
 Atelier Tadeusz Piechura
Art Director
 Tadeusz Piechura
Designer
 Tadeusz Piechura
Client
 Pierwszy Film/First
 Film/Premier Film
Software/Hardware
 Corel 7, Pentium 200
Printing
 Offset

De Elleboogkerk Postbus 699 / NL - 3800 AR Amersfoort
Langegracht 36 / T 033 461 40 88 / F 033 464 05 50
armando.museum@worldonline.nl

ARMANDO**MUSEUM**

Paul Coumans / Directeur

Design Firm
Opera Grafisch Ontwerpers
Art Directors
Ton Homburg, Marty Schoutsen
Designers
Sappho Panhuysen,
Marty Schoutsen
Client
Armando Museum
Software/Hardware
QuarkXpress, Macintosh
Paper/Materials
Distinction Prestige
Printing
Drukkerij Printing Amersfoort

De Elleboogkerk Postbus 699 / NL - 3800 AR Amersfoort
Langegracht 36 / T 033 461 40 88 / F 033 464 05 50
armando.museum@worldonline.nl

ARMANDO**MUSEUM**

Henk Panjer / Beheerder

De Elleboogkerk Postbus 699 / NL - 3800 AR Amersfoort
Langegracht 36 / T 033 461 40 88 / F 033 464 05 50
armando.museum@worldonline.nl

ARMANDO**MUSEUM**

Miriam Windhausen / **Conservator**

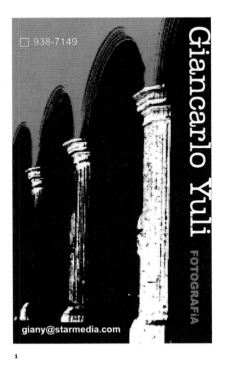

1

1
Design Firm
 S & S Design
Art Director
 Mónica Sánchez Farfán
Designer
 Mónica Sánchez Farfán
Photographer
 Giancarlo Yuli
Client
 Giancarlo Yuli, Photographer
Software/Hardware
 Adobe Photoshop 5.0,
 QuarkXpress 4.0, Zbmaptiva
Paper/Materials
 White Fine Cardboard
Printing
 Valdez Printers

2
Design Firm
 400 Communications Ltd.
Art Director
 Peter Dawson
Designer
 Peter Dawson
Client
 Opus Furniture Limited
Software/Hardware
 QuarkXpress, Macintosh
Printing
 2 Special Colors

Jonathan Crabtree

Opus Furniture Limited

5 Sandy's Row London E1 7HW
Telephone: +44 (0)171 247 2224 Fax: +44 (0)171 247 1168

Opus

2

i f a ▌ Institute for Foreign
Cultural Relations

i f a ▌ Institut für Auslands-
beziehungen e. V.

Postfach 10 24 63
70020 Stuttgart

Charlottenplatz 17
70173 Stuttgart

Tel. 0711 / 22 25-0
Fax 0711 / 2 26 43 46

e-mail: info@ifa.de
http://www.ifa.de

P. O. Box 10 24 63
D-70020 Stuttgart

Charlottenplatz 17
D-70173 Stuttgart

Tel. 0049-711 / 22 25-0
Fax 0049-711 / 2 26 43 46

e-mail: info@ifa.de
http://www.ifa.de

1

1
Design Firm
 Michael Kimmerle·Art
 Direction + Design
Art Director
 Michael Kimmerle
Designer
 Michael Kimmerle
Client
 Institut für
 Auslandsbeziehungen e.V.
Software/Hardware
 QuarkXpress, Macintosh
Paper/Materials
 Diplomat
Printing
 Offset

2
Design Firm
 R & M Associati Grafici
Art Director
 Di Somma/Fontanella
Client
 Self-promotion
Software/Hardware
 Adobe Illustrator, Macintosh
Printing
 Offset

MAURIZIO DI SOMMA · 80053 CASTELLAMMARE DI STABIA_ITALIA · TRAVERSA DEL PESCATORE 3 · RAFFAELE FONTANELLA · **R&M**ASSOCIATI**GRAFICI** · COMUNICAZIONE VISIVA · TELEFONO +39 081 870 50 53_FAX 0818702195

2

Design
 Firm Stang
Designer
 Stang Gubbels
Client
 Self-promotion
Software/Hardware
 QuarkXpress, Macintosh
Paper/Materials
 Graniet
Printing
 Offset

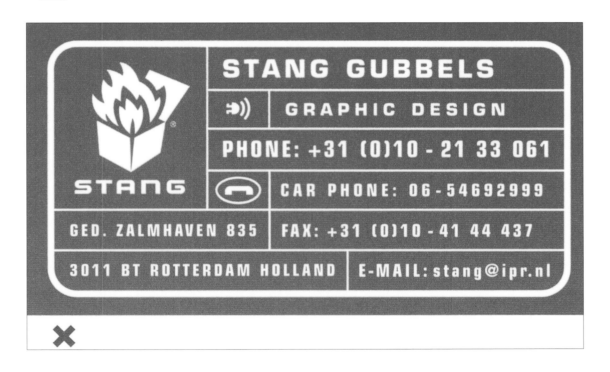

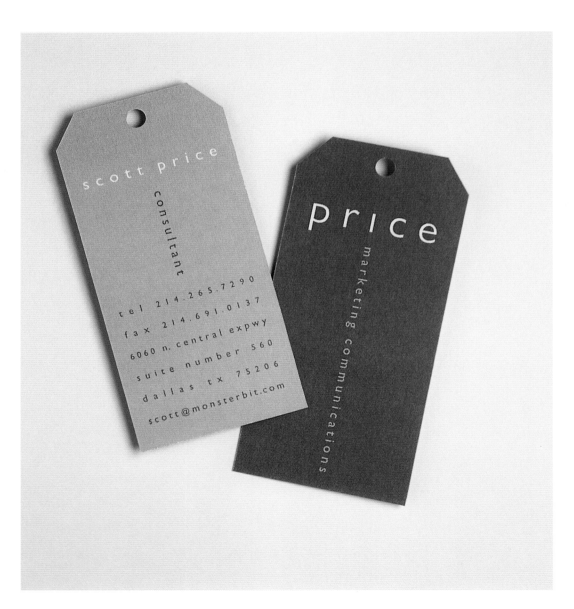

Design Firm
 Joy Price
Designer
 Joy Price
Client
 Scott Price, Price Marketing
 Communications
Software/Hardware
 Adobe Illustrator, Macintosh
Printing
 Digitally Printed on
 Chromapress System;
 Corners Trimmed by Hand;
 Punched by Hand

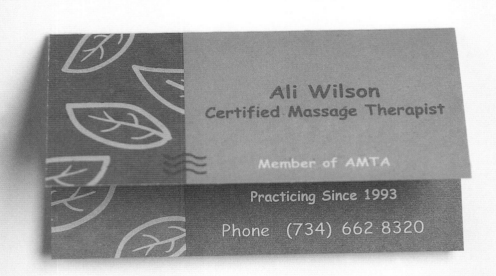

Design Firm
Spectrum Graphics Studio
Designer
Joanne Spangler
Illustrator
Joanne Spangler
Client
Ali Wilson, Ali Wilson Massage
Software/Hardware
Adobe Illustrator 8.0
Paper/Materials
Wausau Royal Fiber, Balsa 80
lb. Cover
Printing
Spectrum Printers; 3 PMS:
Bronze 876, Yellow 124,
Orange 718

MARKETING BRAINS
creative soul

creative CULMINATOR

MIKE PEMBERTON
mikeyp@creativeco.com

CREATIVE COMPANY

3276 Commercial St SE Suite 2
Salem Oregon 97302
l 503.363.4433 Fax 503.363.6817

www.creativeco.com

Design Firm
 Creative Company
Art Director
 Matt Davis
Designer
 Matt Davis
Client
 Self-promotion
Software/Hardware
 Macintosh
Paper/Materials
 Strobe Dull Cover
Printing
 K.P. Corporation

1
Design Firm
　　Bruce Yelaska Design
Art Director
　　Bruce Yelaska
Designer
　　Bruce Yelaska
Client
　　Bikram's Yoga College of India
Software/Hardware
　　Adobe Illustrator
Paper/Materials
　　Strathmore Writing Wove
Printing
　　Offset, Vision Printing

2
Design Firm
　　Kan & Lau Design Consultants
Art Director
　　Kan Tai-Keung
Designers
　　Kan Tai-Keung, Lam Wai Hung
Client
　　Friends of Mine Group Limited
Software/Hardware
　　Freehand 8.0
Paper/Materials
　　300 gsm High White Wove
　　(Conqueror)
Printing
　　Offset

BIKRAM'S

YOGA

COLLEGE OF INDIA

Robin Schmidt
Director

1816 Magnolia Ave.
Burlingame, CA 94010
Tel: 650.552.9642 (YOGA)
www.bikramyoga.com

1

友 福 集 團 有 限 公 司
FRIENDS *of* MINE GROUP LIMITED

Unit 302, 3/F
38 Russell Street
Causeway Bay, Hong Kong
Tel (852) 2545 3635
Fax (852) 2970 2226

Eva S. W. Fung
Assistant to Managing Director

Mobile Phone 9473 2350

2

友 福 集 團 有 限 公 司
FRIENDS *of* MINE GROUP LIMITED

香 港 銅 鑼 灣
羅 素 街 38 號 3 樓 302 室
電 話 (852) 2545 3635
傳 真 (852) 2970 2226

馮 瑞 華
董 事 總 經 理 助 理

手 提 電 話 9473 2350

1

1
Design Firm
 Inox Design
Art Director
 Mauro Pastore
Designer
 Mauro Pastore
Client
 FA.MA.
Software/Hardware
 Adobe Illustrator, QuarkXpress
Printing
 Offset, 3 & 1 Color

afterhours

pt Grafika Estetika Atria
Jalan Merpati Raya 45, Jakarta 12870, Indonesia
tel +62 21 8306819 fax +62 21 8290612
e.mail info@afterhours.co.id

afterhours

2

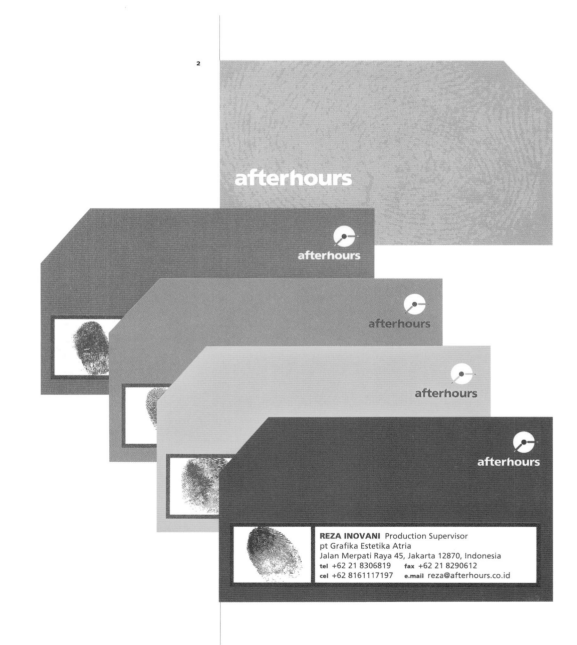

2

2
Design Firm
 Afterhours: pt Grafika
 Estetika Atria
Art Director
 Lans Brahmantyo
Designer
 Lans Brahmantyo
Client
 Self-promotion
Software/Hardware
 Freehand 8
Paper/Materials
 Fox River Superfine Eggshell
Printing
 Harapan Prima

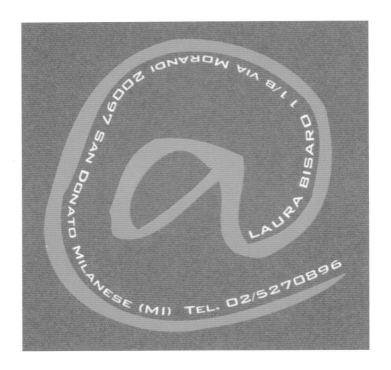

Design Firm
Inox Design
Art Director
Masa Magnoni
Designer
Mauro Pastore
Illustrator
Masa Magnoni
Client
Laura Bisaro
Software/Hardware
Adobe Illustrator
Printing
Offset, 1 Color

1
Design Firm
 400 Communications Ltd.
Art Director
 David Coates
Designer
 David Coates
Illustrator
 David Coates
Client
 Self-promotion
Software/Hardware
 QuarkXpress, Adobe Photoshop,
 Macintosh
Paper/Materials
 300 gsm
Printing
 1 Special, Process Blue

2
Design Firm
 Troller Associates
Art Director
 Fred Troller
Designer
 Fred Troller
Client
 Primo
Paper/Materials
 Strathmore, Bristol
Printing
 Offset

David Coates
graphic designer

m 0958 503348 t 0181 547 2356
34a Southsea Road Kingston upon Thames Surrey KT1 2EH

1

John M. Tremaine
President

114 Washington Street
South Norwalk CT 06854
203.866.4321

Finance Manager
Bomie S.Y. Chan

 FRUITO RICCI

[*Office*]
Unit 302, 3/F., 38 Russell Street, Causeway Bay, Hong Kong
Tel 2545 3635 Fax 2970 2226

[*Shop*]
Shop 7C, G/F., Site 1, Whampoa Garden, Hunghom, Kowloon
Tel 2363 8618, 2363 8622 Fax 2363 8210

[寫 字 樓]
香港銅鑼灣羅素街38號3樓302室
電話 2545 3635 傳真 2970 2226

[店 舖]
九龍紅磡黃埔花園第一期商場7C
電話 2363 8618, 2363 8622 傳真 2363 8210

Design Firm
 Kan & Lau Design Consultants
Art Directors
 Kan Tai-Keung, Eddy Yu Chi Kong
Designers
 Eddy Yu Chi Kong, Lam Wai Hung
Illustrator
 Eddy Yu Chi Kong
Client
 Fruito Ricci Holdings Co. Ltd.
Software/Hardware
 Freehand 8.0
Paper/Materials
 (Wiggins Teape) Zanders CX700,
 White 250 gsm
Printing
 Offset

Design Firm
Kan & Lau Design
Consultants

Art Director
Freeman Lau Siu Hong

Designer
Stephen Lau

Client
Hong Kong Institute of
Contemporary Culture

Software/Hardware
Freehand 7.0

Paper/Materials
260 gsm Art Card

Printing
Offset 3 x 2 (spot) C

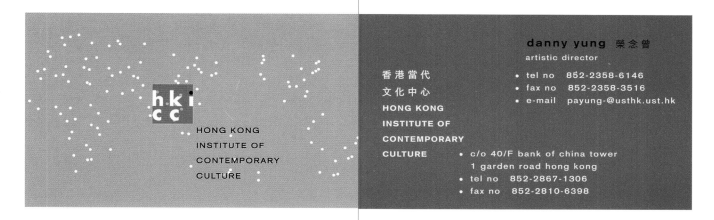

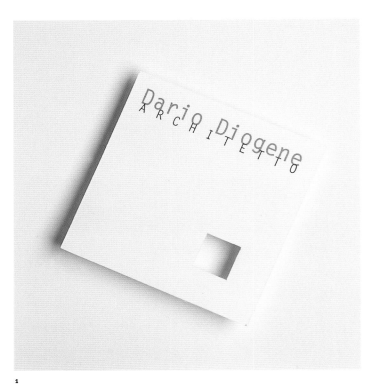

1

Design Firm
R & M Associati Grafici
Art Director
Di Somma/Fontanella
Client
Dario Diogene
Software/Hardware
Adobe Illustrator, Macintosh
Printing
Offset

2
Design Firm
Kan & Lau Design Consultants
Art Director
Freeman Lau Siu Hong
Designer
Freeman Lau Siu Hong
Client
Cheung Yee
Software/Hardware
Freehand 7.0 C
Paper/Materials
Gulliver 197 gsm - CL170 1
Printing
Offset

1

2

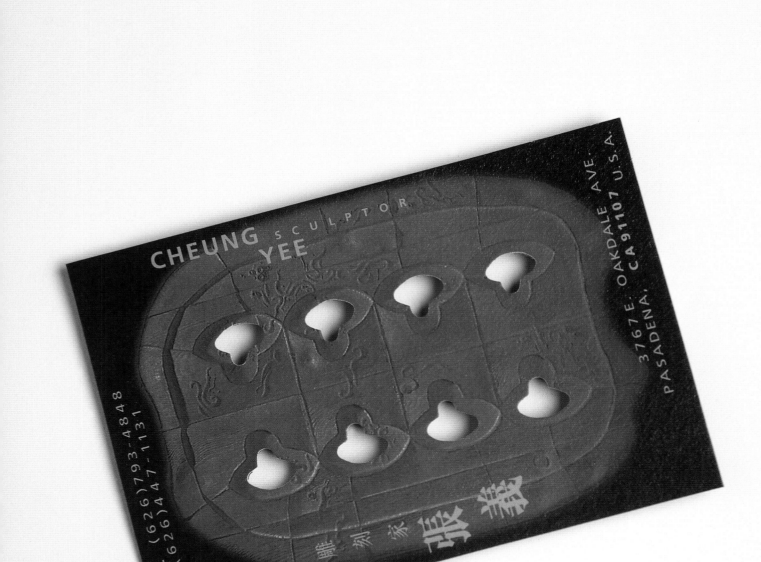

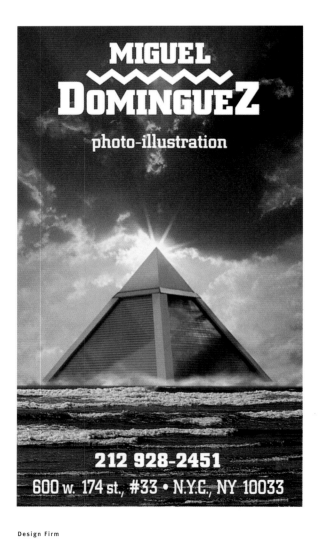

Design Firm
 MD Studio
Designer
 Miguel Dominguez
Illustrator
 Miguel Dominguez
Photographer
 Miguel Dominguez
Client
 Self-promotion
Software/Hardware
 Adobe Photoshop, QuarkXpress

offices in London and Paris visit our website: www.crabtreehall.com

David S. Mackay
Partner

Crabtree Hall
BRANDED ENVIRONMENTS

70 Crabtree Lane
London SW6 6LT
T: +44 (0)20 7381 8755
F: +44 (0)20 7385 9575
E: david@crabtreehall.com

Design Firm
Crabtree Hall
Art Director
David S. Mackay
Designer
David Storey
Client
Self-promotion
Software/Hardware
QuarkXpress, Macintosh
Paper/Materials
Conqueror CX22 320 gsm
Printing
Benwell Sebard

OPERA

ELLIS VAN MULLEKOM

ONTWERPERS

Baronielaan 78
4818 RC Breda

T +31 (0)76 514 75 96
F +31 (0)76 514 82 78
e-mail operath@knoware.nl

OPERA

1
Design Firm
 Opera Grafisch Ontwerpers
Art Directors
 Marty Schoutsen, Ton Homburg
Designers
 Stefanie Rôsch, Ton Homburg
Client
 Opera Ontwerpers
Software/Hardware
 QuarkXpress, Macintosh
Paper/Materials
 Conqueror Vergé
Printing
 Plantijn Casparie Breda

HOBOKEN

GRAND CAFÉ (H) HOBOKEN BV WESTZEEDIJK 343 3015 AA ROTTERDAM
TELEFOON: 010. 225 05 60 FAX: 010. 225 04 42

ONDERDEEL VAN MÂITRE FRÉDÉRIC CATERING & EVENTS
VOOR RESERVERINGEN KUNT U BELLEN 010. 522 03 40

2

2
Design Firm
 Stang
Art Director
 Stang Gubbels
Designer
 Anneke Van Der Stelt
Client
 Grand Café Hoboken
Software/Hardware
 QuarkXpress, Macintosh
Paper/Materials
 Mat Mc
Printing
 Offset

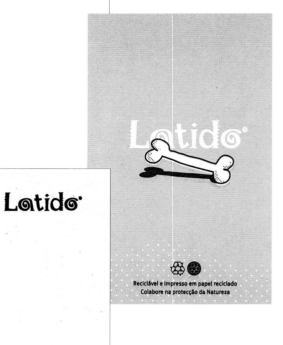

1
Design Firm
Vestígio
Art Director
Emanuel Barbosa
Designer
Emanuel Barbosa
Illustrator
Emanuel Barbosa
Client
Latido - Pet Shop
Software/Hardware
Freehand, Macintosh
Paper/Materials
Renova Print

STACEY TOWNS

677 TULIP AVENUE
COTTAGEVILLE, TEXAS 90018
908.887.5407

2
Design Firm
Scraps arternative designs
Art Director
Patrice M. Bavos
Designer
Patrice M. Bavos
Illustrator
Patrice M. Bavos
Client
Stacey Towns
Paper/Materials
Wasam Bright Cover 80 lb.
with PMS
Printing
Cyclone Printing, Inc.

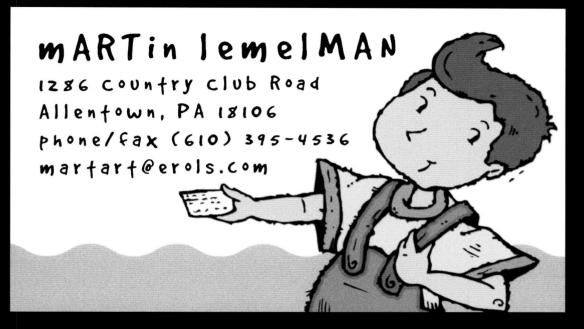

Design Firm
 Martin LemelmanIllustration
Designer
 Martin Lemelman
Illustrator
 Martin Lemelman
Client
 Self-promotion
Software/Hardware
 Adobe Illustrator 8.0

Design Firm
be

Art Director
Will Burke

Designers
Eric Read, Yusuke Asaka

Client
Self-promotion

Software/Hardware
Adobe Photoshop, Adobe
Illustrator, Macintosh

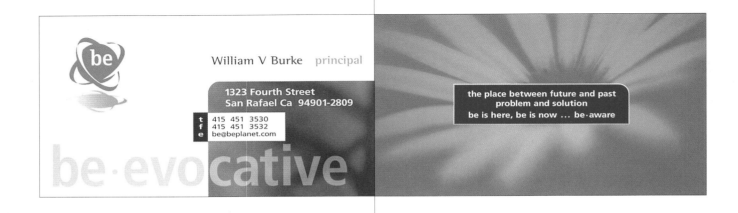

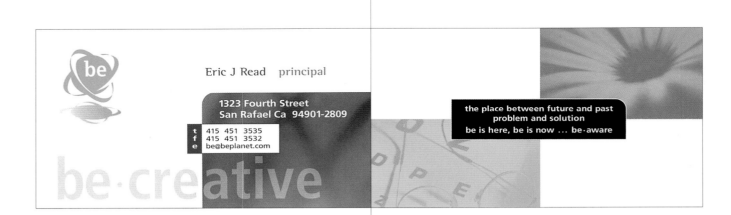

William V Burke

be.next

will_burke@beplanet.com
E 415 451 3530
T
F 415 451 3532

1323 Fourth Street
San Rafael · CA · 94901-2809

Angela Hildebrand

be.next

angela_hildebrand@beplanet.com
E 415 451 3530
T
F 415 451 3532

1323 Fourth Street
San Rafael · CA · 94901-2809

Eric J Read

be.next

eric_read@beplanet.com
E 415 451 3530
T
F 415 451 3532

1323 Fourth Street
San Rafael · CA · 94901-2809

Carissa E Guirao

be.next

carissa_guirao@beplanet.com
E 415 451 3530
T
F 415 451 3532

1323 Fourth Street
San Rafael · CA · 94901-2809

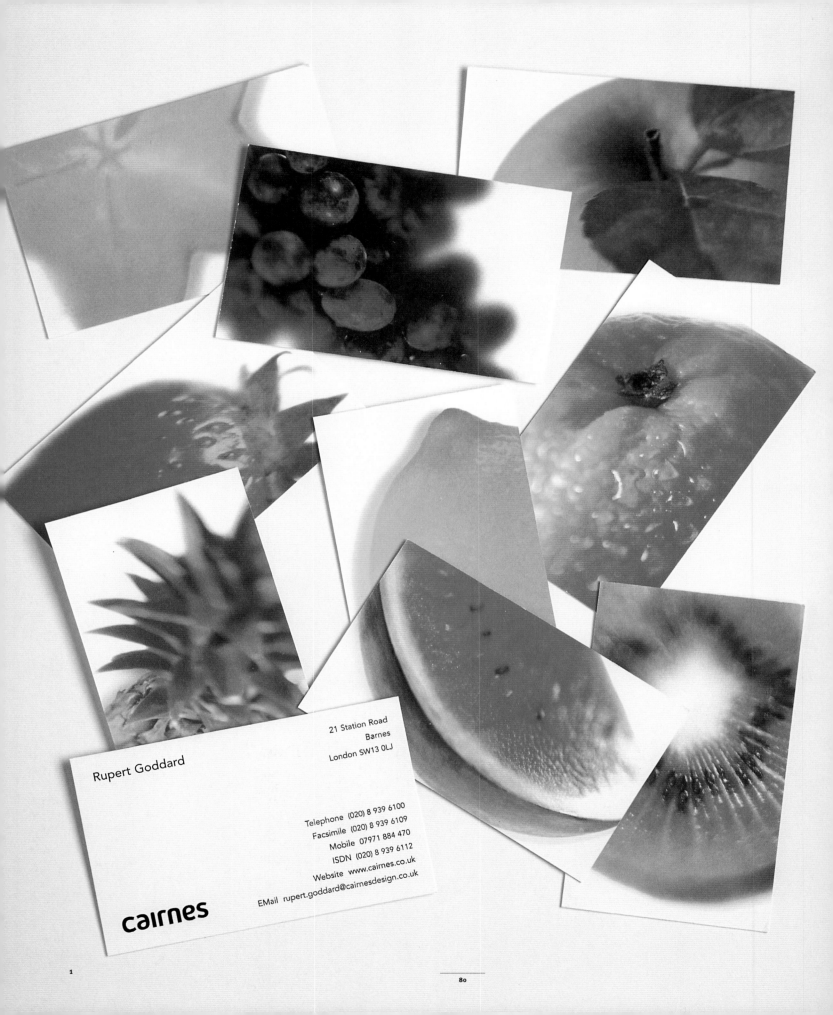

Rupert Goddard

21 Station Road
Barnes
London SW13 0LJ

Telephone (020) 8 939 6100
Facsimile (020) 8 939 6109
Mobile 07971 884 470
ISDN (020) 8 939 6112
Website www.cairnes.co.uk
EMail rupert.goddard@cairnesdesign.co.uk

cairnes

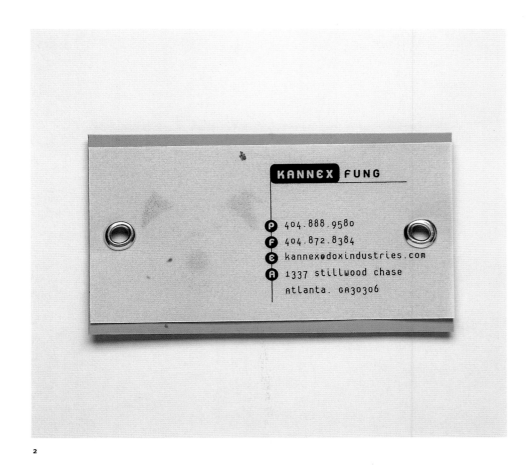

2

1
Design Firm
 Cairnes
Art Director
 Anthony Sharman
Designer
 David Burton
Photographer
 David Burton
Client
 Self-promotion
Software/Hardware
 Quark Xpress
Paper/Materials
 Crane Crest
Printing
 Printed Stationery

2
Design Firm
 DoX Industries
Art Director
 Kannex Fung
Designer
 Kannex Fung
Illustrator
 Kannex Fung
Client
 Self-promotion
Software/Hardware
 Adobe Illustrator
Paper/Materials
 Fox Confetti

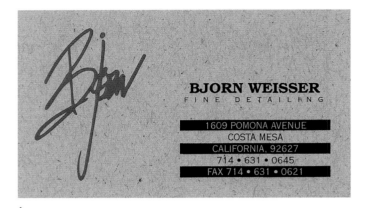

1

BJORN WEISSER
FINE DETAILING

1609 POMONA AVENUE
COSTA MESA
CALIFORNIA, 92627
714 • 631 • 0645
FAX 714 • 631 • 0621

KH

keri hauser

2

HAIR STYLIST

KH

SALON MEI

PAN AM BUILDING

1600 KAPIOLANI

SUITE 222

TEL: 955.1600

PGR: 267.0773

1
Design Firm
 Aloha Printing
Art Director
 James Picquelle
Designer
 James Picquelle
Client
 BJorn Weisser Fine Detailing
Software/Hardware
 Corel Draw
Printing
 Offset Sheet Fed Press

2
Design Firm
 Voice Design
Art Director
 Clifford Cheng
Designer
 Clifford Cheng
Client
 Keri Hauser, Hair Stylist
Software/Hardware
 Freehand, Macintosh
Printing
 Offset, 2 Color

HSB

Hengst Streff Bajko Architects

HSB

Kevin Hengst, AIA

1250 Old River Road
Suite 201
Cleveland Ohio 44113-1243
e-mail: hsb@cyberdrive.net
216 586 0440 f
216 586 0229 t

Design Firm
 Nesnadny + Schwartz
Art Directors
 Timothy Lachina,
 Michelle Moehler,
 Gregory Oznowich
Designers
 Timothy Lachina,
 Michelle Moehler,
 Gregory Oznowich
Client
 Hengst Streff Bajko Architects
Software/Hardware
 QuarkXpress
Paper/Materials
 Mohawke Superfine White
 Eggshell 80 lb., Mohawke
 Superfine White Eggshell 70 lb.
Printing
 Master Printing

1

peter j. urban
760.737.9397
phone/fax

urbangraphic

1148 Felicita Lane
Escondido, CA 92029-6626

2

1
Design Firm
 Media Bridge
Art Director
 Christopher Sullivan
Designer
 Mark Goss
Client
 Electric Soup
Software/Hardware
 Adobe Illustrator

2
Design Firm
 Urbangraphic
Art Director
 Peter Urban
Designer
 Peter Urban
Illustrator
 Peter Urban
Client
 Self-promotion
Software/Hardware
 Adobe Photoshop,
 Adobe Illustrator
Paper/Materials
 Chromecoat
Printing
 4 Color Process

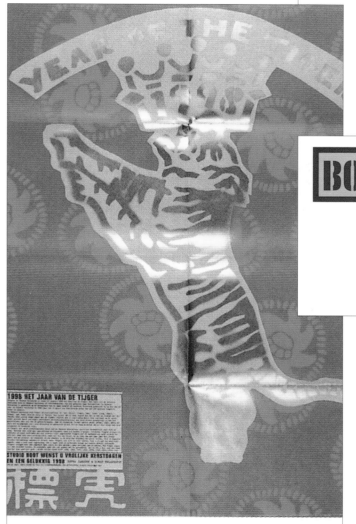

Design Firm
 Studio Boot
Art Directors
 Petra Janssen, Edwin Vollebergh
Designers
 Petra Janssen, Edwin Vollebergh
Illustrator
 Studio Boot
Client
 Self-promotion
Paper/Materials
 MC on 3mm.Grey Board
Printing
 Full Color and Laminate

Design Firm
Cooper-Hewitt, National
Design Museum
Art Director
Jen Roos
Designer
Jen Roos
Client
Self-promotion
Software/Hardware
QuarkXpress 4.04,
Adobe Photoshop
Paper/Materials
100 lb. Mohawk Navajo
Brilliant White
Printing
Aristographics

OLIVER HUMMEL
Assistant Manager
Design Museum Shop

National **Design** Museum

hummeol@ch.si.edu

2 EAST 91ST STREET
NEW YORK, NEW YORK 10128-9990

T 212 849 8353
F 212 849 8357

DIANNE H. PILGRIM
Director

National **Design** Museum

pilgrdi@ch.si.edu

2 EAST 91ST STREET
NEW YORK, NEW YORK 10128-9990

T 212 849 8370
F 212 849 8367

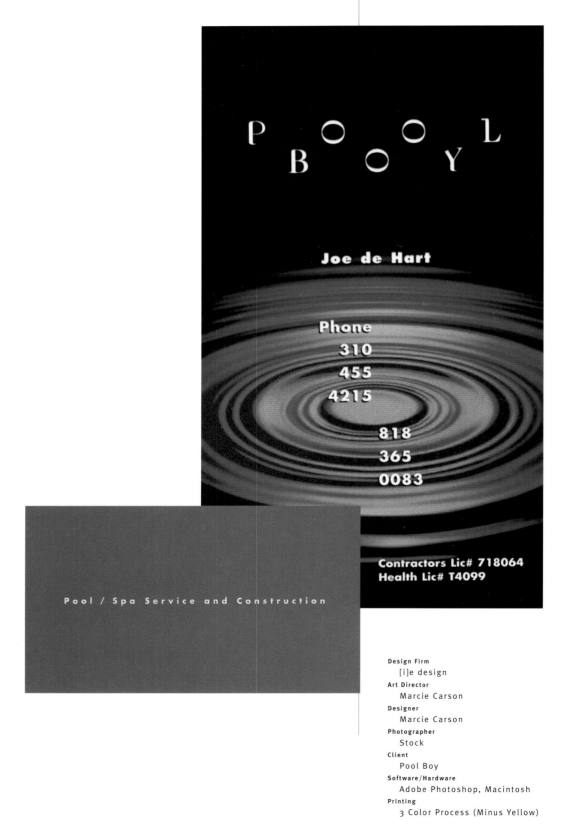

P O O L
B O Y

Joe de Hart

Phone
310
455
4215

818
365
0083

Contractors Lic# 718064
Health Lic# T4099

Pool / Spa Service and Construction

Design Firm
[i]e design
Art Director
Marcie Carson
Designer
Marcie Carson
Photographer
Stock
Client
Pool Boy
Software/Hardware
Adobe Photoshop, Macintosh
Printing
3 Color Process (Minus Yellow)

PHYSIOTHERAPIE CANERI

AMBULANTE REHA

CRYO-POINT −110°C

Francois Caneri
Physiotherapeut

Kriegsbergstraße 28
70174 Stuttgart

Tel. 0711/163 56-0
Fax 0711/163 56-13

Design Firm
Michael Kimmerle·Art
Direction + Design
Art Director
Michael Kimmerle
Designer
Michael Kimmerle
Illustrator
Michael Kimmerle
Client
Pro-moto
Software/Hardware
Freehand, Macintosh
Paper/Materials
Diplomat 250 glm2
Printing
Offset

1
Design Firm
 Inox Design
Art Director
 Masa Magnoni
Designer
 Masa Magnoni
Illustrator
 Masa Magnoni
Client
 Ca' Del Moro
Software/Hardware
 Adobe Illustrator, QuarkXpress
Paper/Materials
 Fibrone 2 mm.
Printing
 Offset, 2 Colors

2
Design Firm
 Visser Bay Anders Toscani
Art Director
 Hilde Lottuis
Designer
 Hilde Lottuis
Client
 Self-promotion
Paper/Materials
 Hello Silk 300 grams

1

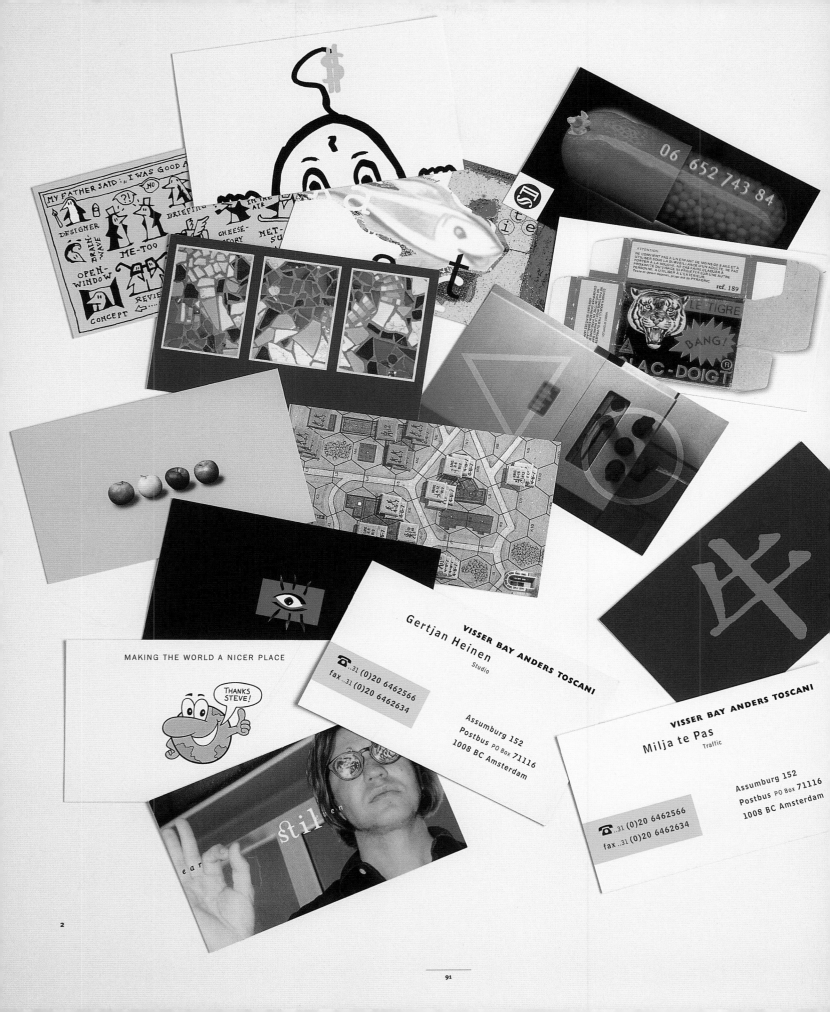

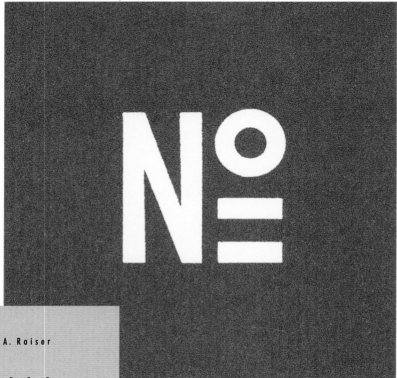

Hartmut A. Raiser

NUMERO
Interior
DESIGN
Olgastrasse 15
7000 Stuttgart 1
No 0711·235757
Fax 0711·293035

Design Firm
Michael Kimmerle·Art
Direction + Design
Art Director
Michael Kimmerle
Designer
Michael Kimmerle
Illustrator
Michael Kimmerle
Client
Numero·Interior Design
Software/Hardware
Freehand, Macintosh
Paper/Materials
Conqueror, Römerturm 200
glm2
Printing
Offset, Prägefolie, Stamping

1
Design Firm
 Michael Kimmerle·Art
 Direction + Design
Art Director
 Michael Kimmerle
Designer
 Michael Kimmerle
Illustrator
 Michael Kimmerle
Client
 Antora Selection
Software/Hardware
 Freehand, Macintosh
Paper/Materials
 Conqueror, Römerturm 250 glm2
Printing
 Offset

2
Design Firm
 Ringo W.K. Hui
Art Director
 Ringo W.K. Hui
Designer
 Ringo W.K. Hui
Client
 Pal Pang 100% Mode
Software/Hardware
 Freehand 8.0
Paper/Materials
 Esse, White Green Texture 216 gsm
Printing
 1 Color, 0 Color

1

2

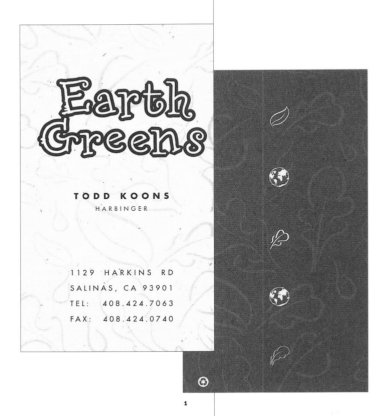

1

1
Design Firm
 The Hive Design Studio
Art Directors
 Laurie Okamura, Amy Stocklein
Designers
 Laurie Okamura, Amy Stocklein
Illustrator
 Pete Caravalho
Client
 Misionero Vegetables
Software/Hardware
 Adobe Illustrator, Macintosh
Paper/Materials
 Strathmore
Printing
 Mission Printers

2
Design Firm
 [i]e design
Art Director
 Marcie Carson
Designer
 David Gilmour
Illustrator
 Mirjam Selmi
Client
 Sunset Sound
Software/Hardware
 Adobe Illustrator, Adobe
 Photoshop, Macintosh
Paper/Materials
 Star White Vicksburg
Printing
 3 PMS, 0 PMS

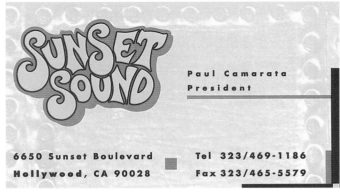

2

Design Firm
Studio Boot
Art Directors
Petra Janssen,
Edwin Vollebergh
Designers
Petra Janssen,
Edwin Vollebergh
Illustrator
Studio Boot
Client
Sacha Shoes
Paper/Materials
Sulfaat Karton
Printing
2 colors, offset
and perforation

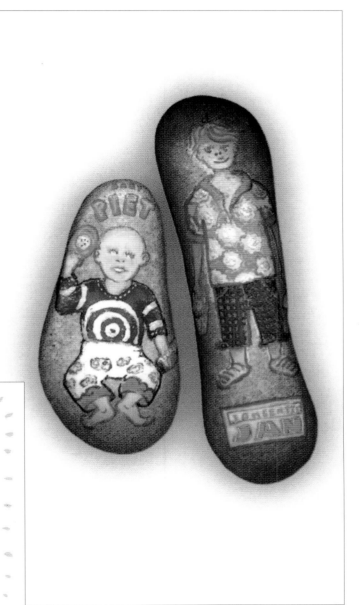

Gespecialiseerd in het maken van:

- historische kleding

- theater- en showbizzkleding

- promotiepakken

- fantasie- en dierenkostuums

- hoeden en maskers

1

1
Design Firm
 Case
Designer
 Kees Wagenaars
Client
 Lizard

2
Design Firm
 Bettina Huchtemann Art-Direction
 & Design
Designer
 Bettina Huchtemann
Illustrator
 Bettina Huchtemann
Client
 Frank Aschermann-Photography
Software/Hardware
 QuarkXpress
Paper/Materials
 Countryside
Printing
 Offset, Steel-Engraving, Embossing

3
Design Firm
 Belyea
Art Director
 Patricia Belyea
Client
 Meredith & crew

2

Meredith Robinson
technology marketing consultant

15127 NE 24th Street
Suite 466
Redmond, WA 98052

tel **206.369.3274**
fax 425.881.3959
meredith@mcrew.com

Meredith Robinson
principal

15127 NE 24th Street
Suite 466
Redmond, WA 98052

tel **206.369.3274**
fax 425.881.3959
meredith@mcrew.com

Meredith Robinson
designer

15127 NE 24th Street
Suite 466
Redmond, WA 98052

tel **206.369.3274**
fax 425.881.3959
meredith@mcrew.com

Meredith Robinson
columnist/writer

15127 NE 24th Street
Suite 466
Redmond, WA 98052

tel **206.369.3274**
fax 425.881.3959
meredith@mcrew.com

Design Firm
Michael Kimmerle·Art
Direction + Design
Art Director
Michael Kimmerle
Designer
Michael Kimmerle
Illustrator
Michael Kimmerle
Client
Self-promotion
Software/Hardware
Freehand, Macintosh
Paper/Materials
Ricarta 260 glm2
Printing
Offset

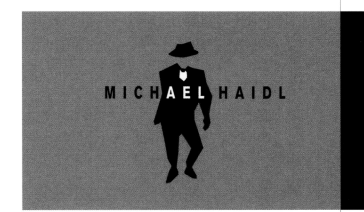

1

MICHAEL HAIDL
alles, was den Mann anzieht
Rheinstraße 14 B
76185 Karlsruhe-Mühlburg
Tel. 0721 / 55 21 20

2

Altamiro Machado
Gestor de Projectos

Estudos de
Desenvolvimento
Económico e Social, Lda.

Av. Central, 45
Tel. 053. 616510/906
Fax 053. 611872
4710 Braga
Portugal

1

Design Firm
Michael Kimmerle·Art
Direction + Design
Art Director
Michael Kimmerle
Designer
Michael Kimmerle
Illustrator
Michael Kimmerle
Client
Michael Haidl
Software/Hardware
Freehand, Macintosh
Paper/Materials
Diplomat/Karton 250 glm2
Printing
Offset

2

Design Firm
Vestígio
Art Director
Emanuel Barbosa
Designer
Emanuel Barbosa
Client
Vector XXI
Software/Hardware
Freehand, Macintosh
Paper/Materials
Torras Paper

1
Design Firm
"That's Nice" l.l.c.
Art Director
Nigel Walker
Designer
Michael McDevitt
Client
United Nations Population Fund
Software/Hardware
Quark XPress, Adobe
Photoshop, Macintosh
Paper/Materials
Potlach Silk 80 lb.
Printing
3/2 PMS

2
Design Firm
Inkwell Publishing Co.
Art Director
Jimmy Hilario
Designer
Jimmy Hilario
Client
University of Asia and the Pacific
Software/Hardware
Freehand 8, Adobe Photoshop 5,
Macintosh
Paper/Materials
Gilclear Heavy Cream 150 gsm
Printing
Offset

2

1

1

Design Firm
Dennis Irwin Illustration
Art Director
Dennis Irwin
Designer
Dennis Irwin
Illustrator
Dennis Irwin
Client
Self-promotion
Printing
Linotext Printing

2

Design Firm
Studio Boot
Art Directors
Petra Janssen, Edwin Vollebergh
Designers
Petra Janssen, Edwin Vollebergh
Illustrator
Studio Boot
Client
Sacha Shoes
Paper/Materials
Sulfaat Karton
Printing
2 colors, offset and perforation

SACHA SHOES

伯特・特米尔
董事長

TERMEE
SAAL VAN ZWANENBERGWEG 10
5026 RN TILBURG
THE NETHERLANDS
PHONE: +31(0)13 4631115
FAX: +31(0)13 4639091
MOBILE: +31 (0)6 53125641
E-MAIL: sacha@sacha.nl
VAT. nr.: NL 007851509 B03

sacha°

SACHA SHOES

BERT TERMEER
PRESIDENT

TERMEER SCHOENEN BV
SAAL VAN ZWANENBERGWEG 10
5026 RN TILBURG
THE NETHERLANDS
PHONE: +31(0)13 4631115
FAX: +31(0)13 4639091
MOBILE: +31 (0)6 53125641
E-MAIL: sacha@sacha.nl
VAT. nr.: NL 007851509 B03

sacha°

2

3
Design Firm
Josh Klenert
Designer
Josh Klenert
Photographer
Josh Klenert
Client
Patricia Brady-Danzig
Software/Hardware
QuarkXpress, Adobe Photoshop,
Adobe Illustrator, **Printing**
2 Color

S C O T T **S T O L L**

P H O T O G R A P H Y

5013 Pacific Highway East #20

Tacoma, Washington 98424

[253] 896-0133

1

1

Design Firm
Belyea

Art Director
Patricia Belyea

Client
Scott Stoll Photography

2

Design Firm
Cisneros Design

Designer
Harry M. Forehand III

Photographer
William Rotsaert

Client
Leapfrog Integrated
Technology Solutions

Software/Hardware
Macintosh

Printing
Aspen Printing,
Albuquerque

LEAPFROG
INTEGRATED TECHNOLOGY SOLUTIONS

LEAPFROG

2050 Botulph Rd. Suite B | Santa Fe, New Mexico 87505
505.988.9279 | Fax 505.988.3101
e-mail LJRice@ix.netcom.com

2

belyea.

Patricia Belyea
PRINCIPAL

patricia@belyea.com

1250 Tower Building
1809 Seventh Avenue
Seattle, WA 98101

206.**682.4895**
FAX 206.623.8912
WEB belyea.com

marketing

communication

design

Design Firm
Belyea
Art Director
Patricia Belyea
Client
Self-promotion

Design Firm
 Sb Design-Brazil
Designer
 Ricardo Bastos
Client
 Tortaria-Sweet Shop
Software/Hardware
 Corel Draw, PC
Paper/Materials
 Couché, Dull, 180 gr
Printing
 Offset

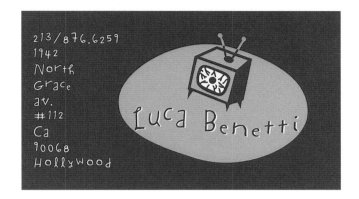

1

2

3

1
Design Firm
 Inox Design
Art Director
 Mauro Pastore
Designer
 Mauro Pastore
Client
 Luca Benetti
Software/Hardware
 Adobe Illustrator
Printing
 Offset, 2 Colors

2
Design Firm
 Izak Podgornik
Designer
 Izak Podgornik
Illustrator
 Izak Podgornik
Client
 Self-promotion
Software/Hardware
 Corel Draw 7, PC
Paper/Materials
 Cordenons Venicelux
 300 glm2
Printing
 2 PMS Colors,
 Plastic Coating

3
Design Firm
 R & M Associati Grafici
Art Director
 Di Somma/Fontanella
Client
 Artemedia
Software/Hardware
 Adobe Illustrator,
 Macintosh
Printing
 Offset

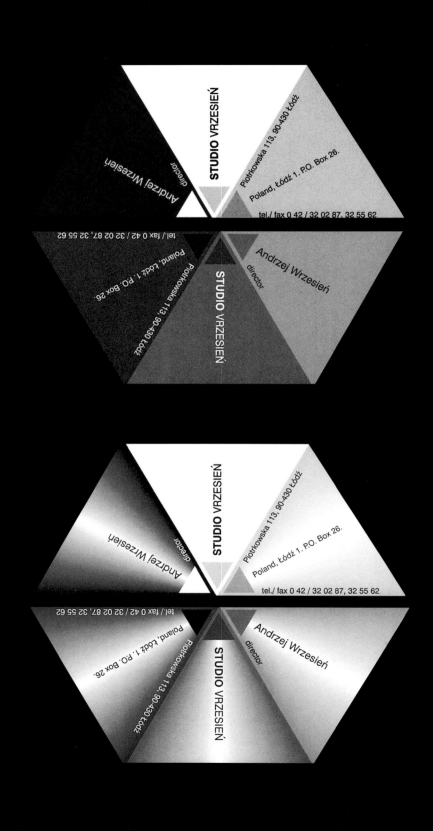

1
Design Firm
 Atelier Tadeusz Piechura
Art Director
 Tadeusz Piechura
Designer
 Tadeusz Piechura
Client
 Studio Vrzesien
Software/Hardware
 Corel 7
Printing
 Offset

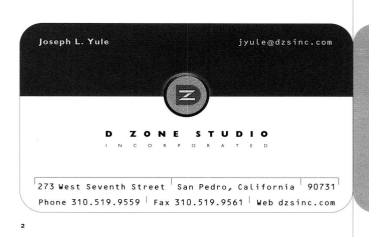

2

2
Design Firm
 D Zone Studio Inc.
Designer
 Joe L. Yule
Client
 Self-promotion
Software/Hardware
 QuarkXpress, Adobe Illustrator
Paper/Materials
 130 lb. Classic Crest -
 Solar White
Printing
 4 Color, Clear Foil, Emboss

Design Firm
 Manhattan Transfer
Art Director
 Micha Riss
Designer
 Patrick Asuncion
Client
 Self-promotion
Software/Hardware
 Adobe Illustrator, Macintosh
Paper/Materials
 Plastic
Printing
 Digicard

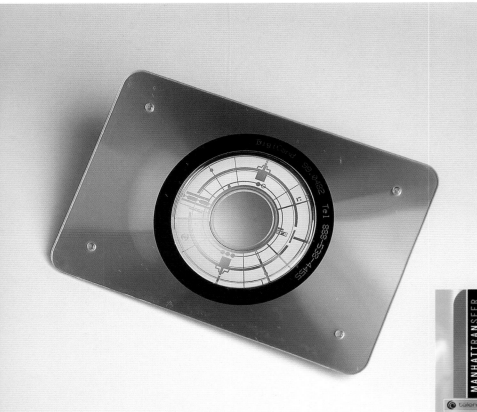

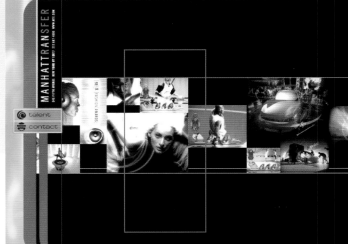

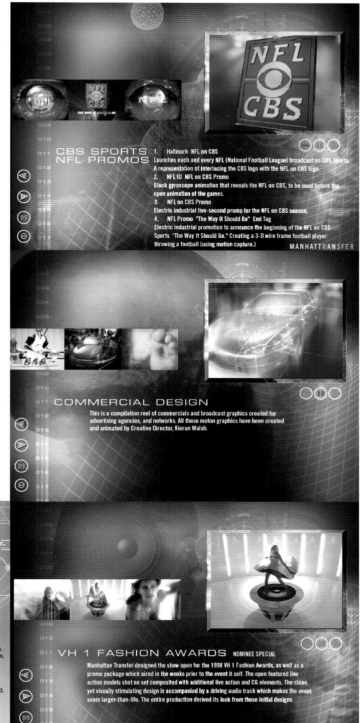

CBS SPORTS NFL PROMOS

1. Hallmark NFL on CBS
Launches each and every NFL (National Football League) broadcast on CBS Sports. A representation of interlacing the CBS logo with the NFL on CBS logo.
2. NFL10 NFL on CBS Promo
Black gyroscope animation that reveals the NFL on CBS, to be used before the open animation of the games.
3. NFL on CBS Promo
Electric industrial five-second promo for the NFL on CBS season.
4. NFL Promo "The Way It Should Be" End Tag
Electric industrial promotion to announce the beginning of the NFL on CBS Sports "The Way It Should Be." Creating a 3-D wire frame football player throwing a football (using motion capture.)

MANHATTRANSFER

COMMERCIAL DESIGN

This is a compilation reel of commercials and broadcast graphics created for advertising agencies, and networks. All these moton graphics have been created and animated by Creative Director, Kieran Walsh.

VH 1 FASHION AWARDS NOMINEE SPECIAL

Manhattan Transfer designed the show open for the 1998 VH 1 Fashion Awards, as well as a promo package which aired in the weeks prior to the event it self. The open featured live action models shot on set composited with additional live action and CG elements. The clean yet visually stimulating design is accompanied by a driving audio track which makes the event seem larger-than-life. The entire production derived its look from these initial designs.

MANHATTRANSFER

micha RISS CREATIVE DIRECTOR

In 1982, Micha Riss designed imagery for record companies and music publications, among them, the VHS cover for the Rolling Stones "25x5". Since 1984, Micha has been designing for television. He worked on numerous sports, news and entertainment events, including SuperBowl, Olympics, NBA, NCAAHoops, US Open Tennis, and The Masters. As of 1990 Micha has focused on total brand identity for television entities.

PROJECTS
CBS, VH-1, ESPN, SCI-FI, Kodak, Merrill Lynch, Museum of Natural History, CNN, Cartoon Network, WGBH (PBS station), HBO, USA Network, Fox, Life Magazine and Sony Music.

AWARDS
• EMMY award, 1994 Winter Olympics on CBS.
• PROMAX award, 1998 Olympic Downhill Promo on CBS.
• ITS MONITOR award, 1998 Olympic Downhill Promo on CBS.
• TELLY award, 1999 Inside the NFL on HBO.

PUBLICATIONS
Life Magazine, Daily News, Computer Graphics World, Digital Photo Illustration, Graphic Design, Click, Leonardo, AdvertisingAge / Creativity, HOW, Art Direction, Design Journal, Backstage, Videography, Video Magazine, Millimeter, Post Magazine, SPIN, Musician, Billboard, International Musician, and Rock Photo.

EDUCATION
TV Graphic Design Instructor in School of Visual Arts, New York City, since 1993.
BFA Computer Graphics, New York Institute of Technology, New York City

MANHATTRANSFER

Petter Frostell Graphic Design

Roslagsgatan 34
SE-113 55 Stockholm, Sweden
Telephone +46 8 442 94 91
Facsimile +46 8 442 94 99
petter.frostell@telia.com

1

1
Design Firm
Petter Frostell Graphic Design
Designer
Petter Frostell
Client
Self-promotion
Software/Hardware
Adobe Illustrator, Macintosh
Paper/Materials
Scandia 2000
Printing
Elfströms Tryckeri

2
Design Firm
Stewart Monderer Design, Inc.
Art Director
Stewart Monderer
Designer
Aime Lecusay
Client
eCredit.com
Software/Hardware
Adobe Illustrator,
QuarkXpress, Macintosh
Paper/Materials
Gilbert Neutech
Printing
2 Match Colors

3
Design Firm
Stewart Monderer Design, Inc.
Art Director
Stewart Monderer
Designer
Aime Lecusay
Client
Crescent Networks, Inc.
Software/Hardware
Adobe Illustrator,
QuarkXpress, Macintosh
Paper/Materials
Monadnock Astrolite
Printing
2 Match Colors

e
Credit.com

Mark S. Hayward
National Account Manager
mark@ecredit.com

www.ecredit.com
1000 Mansell Exchange West, Suite 250 Alpharetta, GA 30022
phone: (770) 645 5257 fax: (770) 645 5258

2

glauer@crescentnets.com

CRESCENT
networks

GREGORY LAUER, PH.D.
founder,
director of product marketing
201 riverneck road chelmsford, ma 01824
t 978 244 9002 x206 c 978 884 4734
f 978 244 9211

3

ZEIGLER ASSOCIATES

107 East Cary Street
Richmond, VA 23219
804.780.1132 | C. BENJAMIN DACUS
804.644.2704 [fax]
zeiglera@erols.com

Marketing
Communications

Design Firm
Zeigler Associates
Art Director
C. Benjamin Dacus
Designer
C. Benjamin Dacus
Client
Self-promotion
Software/Hardware
QuarkXpress
Paper/Materials
French Butcher
Printing
Offset; Business Press,
Richmond, VA

Design Firm
Blue Suede Creative
Art Director
Dave Kennedy
Designer
Justin Baker
Client
Self-promotion
Printing
Ultratech Printing

Dave Kennedy

BLUE SUEDE CREATIVE

2525 ONTARIO STREET
VANCOUVER, B.C., CANADA V5T 2X7

TELEPHONE 604.879.2525 FACSIMILE 604.879.2542
E-MAIL bsuede@istar.ca

buddyproject
deskundigheidsbevordering
telefonische doorverwijzing
informatieverstrekking
opvang naasten en directe omgeving

WEST-BRABANT AIDSSTEUNPUNT

P.J.L. Ernst
voorzitter

Heuvelstraat 151
postbus 1067
4801 bb breda

tel 076 522 86 95
fax 076 522 40 37
awb@casema.net

1

R graphische formgebung

herbert rohsiepe

pulverstraße 25
d-44869 bochum
fon 0 23 27 · 95 76 21
fax 0 23 27 · 95 76 22
isdn 0 23 27 · 95 76 23 (mac)
e-mail herbert.rohsiepe@gelsen.net

2

1
Design Firm
 Case
Designer
 Kees Wagenaars
Client
 Aidssteunpunt West-Brabant
Software/Hardware
 QuarkXpress
Paper/Materials
 Biotop
Printing
 PMS 281, PMS 192

2
Design Firm
 graphische formgebung
Art Director
 Herbert Rohsiepe
Designer
 Herbert Rohsiepe
Client
 Self-promotion
Software/Hardware
 Freehand 8.0, Macintosh
Printing
 Grey, Red, Blue-Grey-Metallic,
 Embossing

Space Needle
Live The View

Doug Bamford
Marketing

203 6th Avenue North
Seattle, WA 98109-5005
Main: (206) 443-9700
Direct: (206) 443-2161, ext.1432
Fax: (206) 441-7415
E-mail: doug@bamford.com

1
Design Firm
 Hornall Anderson Design Works
Art Director
 Jack Anderson
Designers
 Mary Hermes, Gretchen Cook,
 Andrew Smith
Client
 Space Needle
Software/Hardware
 Freehand, Macintosh
Paper/Materials
 Fox River Confetti

 personify

www.personify.com

50 Osgood Place, Suite 100
San Francisco, California 94133

T 415 / 782 2050
F 415 / 544 0318

personify

[EILEEN HICKEN GITTINS]
ceo

415 / 782 2055
egittins@personify.com

2
Design Firm
 Hornall Anderson Design Works
Art Director
 Jack Anderson
Designers
 Jack Anderson, Debra
 McCloskey, Holly Finlayson
Illustrator
 Holly Finlayson
Client
 Personify
Software/Hardware
 Freehand, Macintosh
Paper/Materials
 Regalia

Design Firm
 Hornall Anderson Design Works
Art Director
 Jack Anderson
Designers
 Jack Anderson, Heidi Favour,
 Margaret Long
Client
 Mahlum Architects
Software/Hardware
 Freehand, Macintosh
Paper/Materials
 Mohawk Superfine Recycled,
 White

Design Firm
Visual Marketing Associates
Art Directors
Jason Selke, Tracy Meiners,
Ken Botts
Designer
Jason Selke
Photographer
Quigley
Client
C/ND Snowboard Apparel
Software/Hardware
Freehand 8.0
Paper/Materials
French Frostone
Printing
Patented Printing

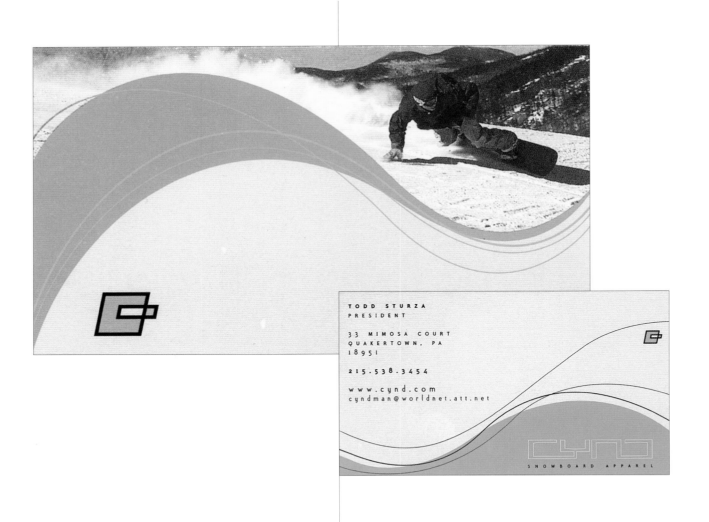

Design Firm
 Form Studio
Art Director
 Jeffrey Burk
Designer
 Jeffrey Burk
Client
 Self-promotion
Software/Hardware
 Strata Studio Pro, Adobe
 Photoshop, Freehand
Paper/Materials
 Havana, Perla 111 lb. Cover
Printing
 Lithography, Letter Press

F O R M S T U D I O I N C.
2900 First Ave P501 Seattle, WA 98121
JEFFREY BURK
TEL 206.448.0275 **FAX** 206.448.0277
EMAIL jeffrey@formstudio.com **WEB** www.formstudio.com
PRINT IDENTITY INTERNET
DESIGN

1

1

Design Firm
O2 Design
Art Director
Peter Dawson
Designer
Peter Dawson
Client
Self-promotion
Software/Hardware
QuarkXpress, Adobe Photoshop,
Macintosh
Paper/Materials
Federal Tait Presentation
300 gsm
Printing
2 Specials and Die cuts

2

Design Firm
Pfeiffer plus Company
Art Director
Jerry Bliss
Designers
Terry Bliss, Katy Fischer
Illustrators
Terry Bliss, Katy Fischer
Client
Self-promotion
Software/Hardware
Adobe Illustrator 8.0,
QuarkXpress 4.0
Paper/Materials
Mohawk Superfine 80 lb. Bright
White Cover
Printing
Reprox

2

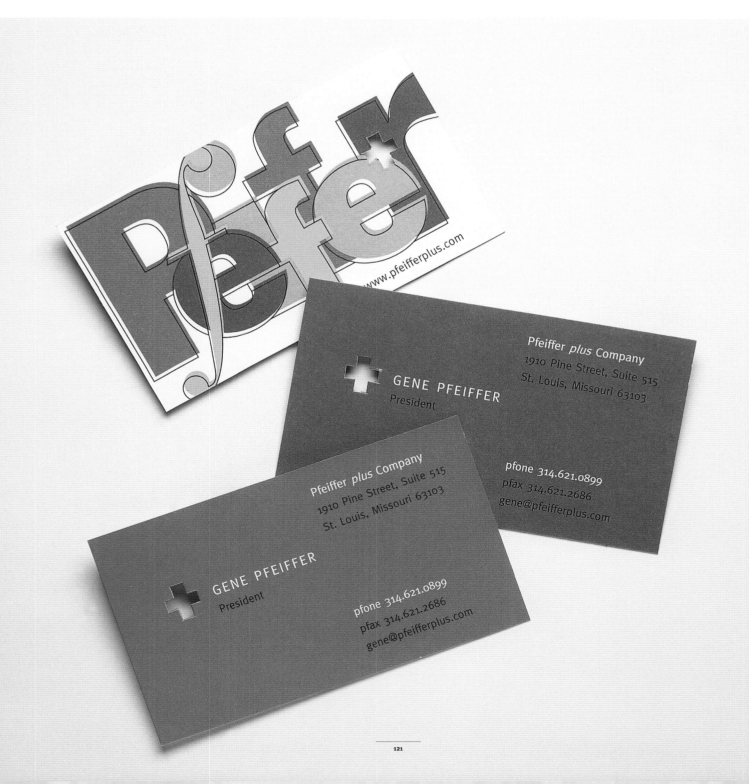

Design Firm
Becker Design
Art Director
Neil Becker
Designers
Neil Becker, Mary Eich
Client
tesserae
Software/Hardware
QuarkXpress, Adobe Illustrator

tesserae

custom tables • fireplace facades
lamps • mirrors • frames • planters

mosaics for life

Tammy Leiner
414.385.0320

Design Firm
Total Creative, Inc.
Art Director
Rod Dyer
Designer
John Sabel
Illustrator
John Sabel
Client
Farrier's Nature
Software/Hardware
Adobe Illustrator, Macintosh

FARRIER'S NATURE
354 HUNTLEY DRIVE
WEST HOLLYWOOD
CALIFORNIA 90048
TEL: 310.289.7701
FAX: 310.289.7719

DENNIS FARRIER

Design Firm
Greteman Group
Art Director
Sonia Greteman
Designer
James Strange
Client
Self-promotion
Software/Hardware
Freehand
Paper/Materials
Light Spec Snow
Printing
Offset

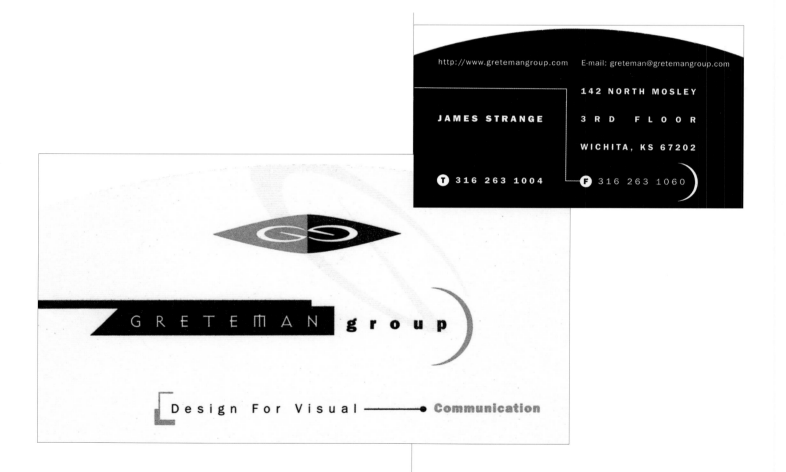

1

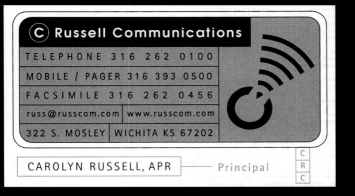

1
Design Firm
Gretem
Art Director
Sonia
Designer
James
Client
Russel
Software/Ha
Freeha
Paper/Mate
Strathi
Printing
Offset

2
Design Firm
Dean J
Art Director
Scott J
Designers
Scott J
Pat Pra
Client
Expida

Design Firm
Opera Grafisch Ontwerpers
Art Directors
Ton Homburg, Marty
Schoutsen
Designer
Sappho Panhuysen
Client
Werk 3
Software/Hardware
QuarkXpress, Macintosh
Paper/Materials
Biotop

1
Design Firm
 Studio Boot
Art Directors
 Petra Janssen, Edwin Vollebergh
Designers
 Petra Janssen, Edwin Vollebergh
Illustrator
 Studio Boot
Client
 Pieksma bv.
Paper/Materials
 Sulfaat Karton
Printing
 Offset, 3 colors

Pieksma bv.
sinds 1889
Medische divisie

Frank Rooijakkers
Achtergracht 27
1017 WL Amsterdam
T.020-6237754 F.020-6245203
privé 020-6937612

1501 to come

Helen Brennan

Sir John Lyon House
5 High Timber Street
Blackfriars
London
EC4V 3NX

tel +44 (0)207 2484945
fax +44 (0)207 2484946
mob +44 (0)467 785786
helen@chameleonmkg.com

chameleon marketing communications

Sir John Lyon House 5 High Timber Street Blackfriars London **EC4**V 3NX

Paul Burgess
T +44 (0)171 420 7700
F +44 (0)171 420 7701
m 0976 607126
paulb@wilsonharvey.co.uk

Wilson Harvey
Contagious Marketing and Design

1

Uday Radia

lighthouse

• Sir John Lyon House
 5 High Timber Street
 London
 EC4V 3NX

• t 020 7420 7714
 f 020 7420 7723

• e uradia@lighthousepr.com
 www.lighthousepr.com

2

Anthony Berry

AC Networks
12 Astra Drive
Gravesend
Kent
DA12 4PY

Tel 01474 350890
Fax 01474 320400

3

1
1500 to come

2
1503 to come

3
1502 to come

The Frame House
video-postproduction

T +31 (35) 21 54 58
F +31 (35) 21 54 50

Michel Carpay

T 06 - 52 73 88 78

...elaan 35 1217 HK Hilversum

Gratis △ 4 0

ptt telecom

Eenheden

4

Design Firm
 Studio Boot
Art Directors
 Petra Janssen, Edwin Vollebergh
Designers
 Petra Janssen, Edwin Vollebergh
Illustrator
 Studio Boot
Client
 Self-promotion
Paper/Materials
 MC on 3mm Grey Board
Printing
 Full Color and Laminate

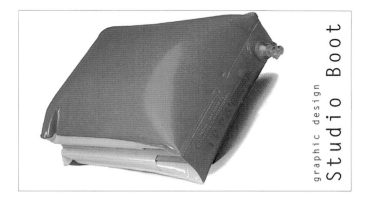

1
Design Firm
 Herman Miller Marketing
 Communications Dept.
Art Director
 Stephen Frykholm
Designer
 Brian Edlefson
Photographers
 Nick Merrick,
 Hedrick Blessing,
 Stock
Client
 Herman Miller, Inc.
Software/Hardware
 Adobe Photoshop 5.0,
 QuarkXpress 4.0
Paper/Materials
 Fox River Coronado
Printing
 Foremost Graphics, Inc.

2
Design Firm
 Atelier Tadeusz Piechura
Art Director
 Tadeusz Piechura
Designer
 Tadeusz Piechura
Client
 Olli Reima
Software/Hardware
 Corel 7
Printing
 Offset, 2nd Edition,
 New Version

2

Design Firm
Hornall Anderson Design Works
Art Director
Jack Anderson
Designers
Jack Anderson, Lisa Cerveny,
Jana Wilson Esser, Nicole Bloss
Illustrators
Nicole Bloss, Jana Wilson Esser
Client
Best Cellars
Software/Hardware
Freehand, Macintosh
Paper/Materials
Proterra Straw 80 lb. C

BEST CELLARS™

1291 LEXINGTON AVE

NEW YORK NY 10128

TEL 212.426.4200

FAX 212.426.9597

PXL8R Visual Communications

Post Office Box 7678
Van Nuys, CA 91409
phone 818.901.9306
fax 818.901.0433
email craig@pxl8r.com
web www.pxl8r.com

CRAIG MOLENHOUSE

1

1
Design Firm
 PXL8R Visual Communications
Designer
 Craig Molenhouse
Photographer
 Craig Molenhouse
Client
 Self-promotion
Software/Hardware
 Adobe Photoshop, Adobe Illustrator, QuarkXpress
Paper/Materials
 Neenah Classic Natural White
Printing
 Clear Print

2
Design Firm
 Greteman Group
Art Directors
 Sonia Greteman, James Strange
Designer
 James Strange
Production Artist
 Jo Quillen
Client
 Golfoto
Software/Hardware
 Freehand
Paper/Materials
 Speckeltone Oatmeal
Printing
 Offset

2

1
Design Firm
 Case
Designer
 Kees Wagenaars
Client
 Seegers & Emmen
Software/Hardware
 QuarkXpress
Paper/Materials
 Lightning Gold 240 gr.
Printing
 Expel

2
Design Firm
 DMX Design
Art Director
 Petrie Hahn
Designer
 Sara Crivello, Suyeon Park
Client
 Self-promotion
Software/Hardware
 Adobe Illustrator

1

2

Design Firm
DMX Design
Art Director
Petrie Hahn
Designer
Sara Crivello
Client
Iscom
Software/Hardware
Adobe Illustrator

ISAAC SALEM
President

Iscom, Inc.
One Silicon Alley Plaza
90 William Street, Suite 1202
New York, NY 10038

p: 212.324.1100
f: 212.324.1101
isaac@iscom.net
www.iscom.net

COPYGRAPHICS

PETER ELLZEY

314 READ STREET

SANTA FE, NM 87505

505 988 1438 VOICE

505 988 3155 FAX

COPYGRAPHICS

BILLMAKER

314 READ STREET

SANTA FE, NM 87501

505 988 1438 VOICE

505 988 3155 FAX

COPYGRAPHICS

DUANE HENRY

314 READ STREET

SANTA FE, NM 87501

505 988 1438 VOICE

505 988 3155 FAX

1

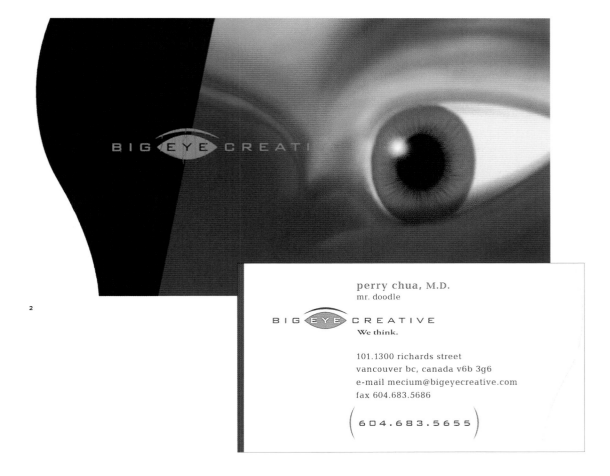

1
Design Firm
 Cisneros Design
Art Director
 Harry M. Forehand III
Designers
 Harry M. Forehand III,
 Brian Hurshman
Client
 Copygraphics
Software/Hardware
 Macintosh
Printing
 Local Color, Santa Fe

2
Design Firm
 Big Eye Creative
Art Directors
 Perry Chua, Dann Ilicic
Designer
 Perry Chua
Photographer
 Grant Waddell
 (digital imaging)
Client
 Self-promotion
Software/Hardware
 Adobe Illustrator,
 Adobe Photoshop
Paper/Materials
 Potlatch McCoy
Printing
 Clarke Printing

2

perry chua, M.D.
mr. doodle

BIG EYE CREATIVE
We think.

101.1300 richards street
vancouver bc, canada v6b 3g6
e-mail mecium@bigeyecreative.com
fax 604.683.5686

(604.683.5655)

TEL 415·482·9324

digital

FAX 415·482·9314

EMAIL ron@dahothouse.com

1323 Fourth Street · San Rafael · CA · 94901

hothouse

1

1
Design Firm
be
Art Director
Will Burke
Designers
Eric Read, Enrique Gaston
Client
hothouse digital
Printing
Photon Press

2
Design Firm
be
Art Director
Will Burke
Designer
Eric Read
Illustrator
Coralie Russo
Client
light rain
Software/Hardware
Adobe Illustrator, Adobe Photoshop,
Macintosh
Printing
Photon Press

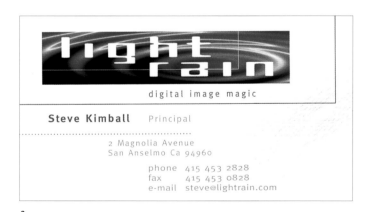

digital image magic

Steve Kimball Principal
..
2 Magnolia Avenue
San Anselmo Ca 94960

phone 415 453 2828
fax 415 453 0828
e-mail steve@lightrain.com

2

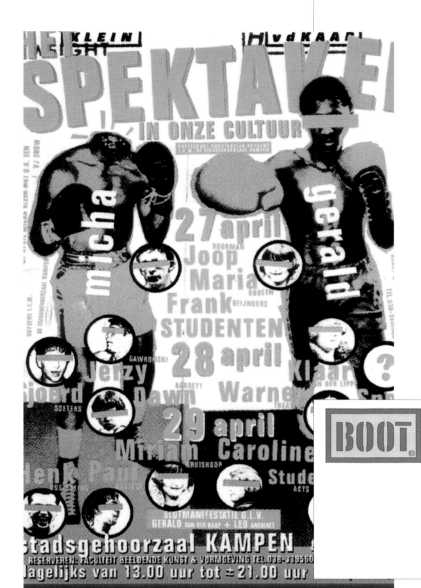

Design Firm
 Studio Boot
Art Directors
 Petra Janssen, Edwin Vollebergh
Designers
 Petra Janssen, Edwin Vollebergh
Illustrator
 Studio Boot
Client
 Self-promotion
Paper/Materials
 MC on 3mm Grey Board
Printing
 Full Color and Laminate

studio Boot • Brede Haven 8a
5211 Tl 's-Hertogenbosch
Tel.073-6143593 • Fax 073-6133190
ISDN 073-6129865 • bootst@wxs.nl

SKY RADIO 100.7 FM

Martin S. Banga
**Manager Public Affairs &
International Development**
Telefoon 035 6991007

Internet www.skyradio.nl *E-mail* skyradio@skyradio.nl

Bezoek Naarderpoort 2, 1411 MA Naarden *Fax* 035 6991098
Post Postbus 1007, 1400 BA Bussum

SKY RADIO 100.7 FM

Fiona Peeters
*Account Manager
Joint Promotions*
Telefoon 035 6991007

Bezoek Naa
Post Postbus 1007, 14

SKY RADIO 100.7 FM

Bonnie Blok
Account Ma
Telefoon 035 69

SKY RADIO 100.7 FM

Barry den Hartog
Sales Directeur
Telefoon 035 6991007

Bezoek Naarderpoort 2, 1411 MA Naarden *Fax* 035 6991008
Post Postbus 1007, 1400 BA Bussum

Internet www.skyradio.nl *E-mail* Barry.den.Hartog@skyradio.nl *Mobiele telefoon* 0653 185546

SKY RADIO 100.7 FM

Anne-Mief Pang
Account Manager
Telefoon 035 6991007

Bezoek Naarderpoort 2,
Post Postbus 1007, 1400 BA Bussum

unt Manager
91007
Bezoek Naarderpoort 2, 1411 MA Naarden
Post Postbus 1007, 1400 BA Bussum
Fax 035 6991008

MA Naarden
Fax 035 6991022
Internet www.skyradio.nl
E-mail Fiona.Cordes@skyradio.nl
Mobiele telefoon 0653 591463

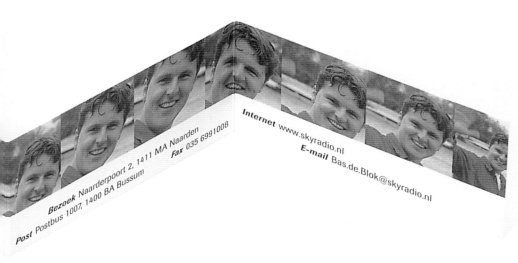

Bezoek Naarderpoort 2, 1411 MA Naarden
Post Postbus 1007, 1400 BA Bussum
Fax 035 6991008
Internet www.skyradio.nl
E-mail Bas.de.Blok@skyradio.nl

den
5 6991008
Internet www.skyradio.nl
E-mail Annemiek.Papo@skyradio.nl
Mobiele telefoon 0655 893177

Design Firm
 Visser Bay Anders Toscani
Art Director
 Teun Anders
Designer
 Wendy Mooren
Photographer
 Lex Verbeek
Client
 Sky Radio
Paper/Materials
 Pro Mail Plus 250 gr.

Design Firm
IUADOME
Art Director
Sang Han
Designers
Jeeho Kim, Sung
Hyun Park
Photographer
Chang Han
Client
Self-promotion
Software/Hardware
Adobe Illustrator,
Adobe Photoshop, 3D Max
Paper/Materials
65 lb. Cougar White,
Cellophane
Printing
Mcbride Printing

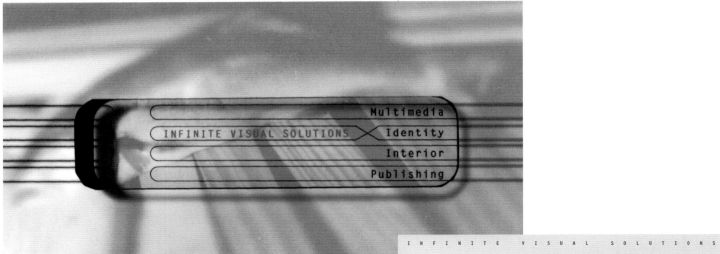

DETERMAN BROWNIE, INC.

Ron Determan

Field Service

1241 72nd Avenue NE
Minneapolis, MN 55432

PHONE: 612.571.8110 | FAX: 612.502.9862

1

DIGITAL MEDIA GROUP

2

Digital Media Group s.r.l.
Via Tadino 20 20124 Milano
tel 02 29.41.21.74 Fax 02 29.41.52.66
e-mail: monti@dmg it
Punto Vendita Autorizzato Apple Computer
Partita Iva 12365290159

Auro Monti

1
Design Firm
 Design Center
Art Director
 John Reger
Designer
 Jon Erickson
Client
 Determan Brownie, Inc.
Software/Hardware
 Freehand, Macintosh
Paper/Materials
 Strathmore Writing

2
Design Firm
 Inox Design
Art Director
 Sabrina Elena
Designer
 Sabrina Elena
Client
 Digital Media Group
Software/Hardware
 Freehand
Paper/Materials
 Zanders Chromolux
Printing
 Offset, 1 & 2 Colors

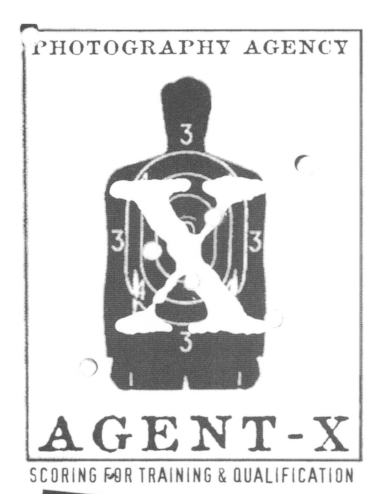

Design Firm
Studio Boot
Art Directors
Petra Janssen,
Edwin Vollebergh
Designers
Petra Janssen,
Edwin Vollebergh
Illustrator
Studio Boot
Client
AGENT-X
Paper/Materials
Chromolux
Printing
Offset

PHILIPPE G. VADALEAU

SCHRÖDERSTIFTSTR. 28 / 20146 HAMBURG / TEL.: 040 · 41 81 11 / FAX: 41 82 10

Design Firm
Bettina Huchtemann Art -
Direction & Design
Designer
Bettina Huchtemann
Illustrator
Bettina Huchtemann
Client
Philippe Vadaleau
Software/Hardware
QuarkXpress, Brush
Paper/Materials
Countryside
Printing
Offset, 2 Colors

Jed Somit, Attorney (415) 839-3215

1440 Broadway, Suite 910
Oakland, California 94612
FAX (415) 272-0711

1

1
Design Firm
Fifth Street Design
Art Director
J. Clifton Meek
Designer
Brenton Beck
Client
Jed Somit
Software/Hardware
Corel Draw
Paper/Materials
Strathmore Writing Laid
Printing
Kerwin Graphic Arts

3
Design Firm
Zeroart Studio
Art Director
Josef Lo
Designer
Simon Tsang
Client
Self-promotion
Software/Hardware
Adobe Illustrator 8.0, Macintosh
Paper/Materials
Rives Paper, Bright White 250 gsm
Printing
Charming Print
Production House

2 (see also page 149, bottom)
Design Firm
Esfera Design
Designers
Cecilia Consolo, Luciano Cardinali
Client
Self-promotion
Software/Hardware
QuarkXpress, Corel Draw
Paper/Materials
Star White Vicksburg, Tiara 216 g
Printing
Offset

[E S F E R A D E S I G N
design & assessoria de imagem

rua barão de santa marta, 519 04372-100 são paulo sp
fone/fax: (0++11) 5563 1454 Cel: (0++11) 9611 3023

Luciano Cardinali

c r e a t i v i t y - a l w a y s . o n . m y . m i n d

* *simon tsang*曾繁光 *chief designer*
zeroart@netvigator.com * p.o.box 71466, kowloon central post office, hong kong.
* tel / fax 26 09 40 50

93 04 36 09

3

Luciano Cardinali

ESFERA DESIGN
design & assessoria de imagem

rua barão de santa marta 519 são paulo sp 04372-100
fone fax (0++11) **5563 1454** Cel (0++11) 9611.3023
e s f e r a d g @ u o l . c o m . b r

1
Design Firm
 Erwin Zinger Graphic Design
Designer
 Erwin Zinger
Client
 Hans Kliphuis Public Relations & Public
 Affairs
Software/Hardware
 Adobe Illustrator, QuarkXpress
Paper/Materials
 Countryside
Printing
 2 Colors, Offset

2
Design Firm
 Erwin Zinger Graphic Design
Designer
 Erwin Zinger
Client
 Poggibonsi
Software/Hardware
 Adobe Illustrator
Paper/Materials
 Confetti
Printing
 Black and Silver (PMS 877)

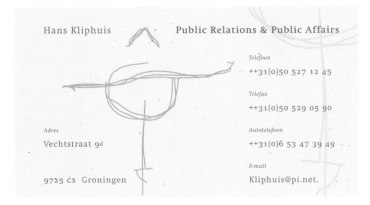

1

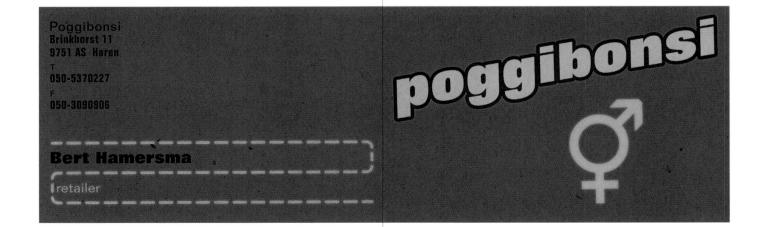

2

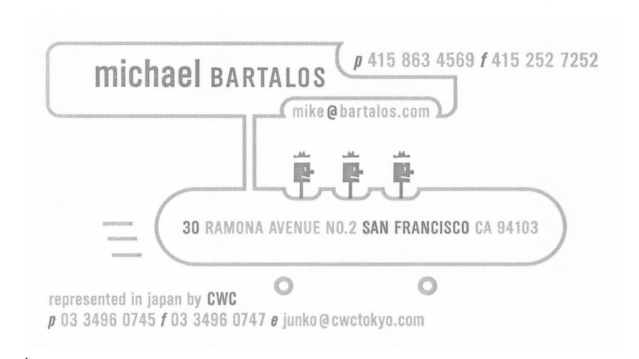

1

2

1
Design Firm
 Natto Maki
Art Director
 Lili Ong
Designer
 Lili Ong
Illustrator
 Michael Bartalos
Client
 Michael Bartalos
Software/Hardware
 Adobe Illustrator
Paper/Materials
 Strathmore Off-White Cover
Printing
 Letter Press By One Heart Press,
 San Francisco

2
Design Firm
 Design Center
Art Director
 John Reger
Designer
 Sherwin Schwartzrock
Client
 Cameleon
Software/Hardware
 Freehand, Macintosh
Paper/Materials
 Strathmore Writing
Printing
 Pro-Craft

1

Design Firm
Via Vermeulen

Art Director
Rick Vermeulen

Designer
Rick Vermeulen

Photographer
Jeroen Musch

Client
West 8 Architects & Planners

2

Design Firm
Michael Kimmerle·
Art Direction + Design

Art Director
Michael Kimmerle

Designer
Michael Kimmerle

Client
Florath·Drehtechnik

Software/Hardware
Freehand, Macintosh

Paper/Materials
Chromolux Zanders

Printing
2x Prägefolie, Offset

Design Firm
Cincodemayo Design
Art Director
Mauricio H. Alanis
Designer
Adriana Garcia
Client
BAR-CELONA
Software/Hardware
Freehand 8.01, Macintosh
Paper/Materials
Magnomatt 250
Printing
5OM Offset Printing

SEQUENCE
PLANNING & DESIGN

INTERIOR DESIGN

SPACE PLANNING

PROJECT MANAGEMENT

MOVE COORDINATION

1

SEQUENCE
PLANNING & DESIGN

DOTTIE BRIGGS
ASID • IFMA

883 NORTH SHORELINE BLVD., SUITE C-120
MOUNTAIN VIEW, CA 94043

TEL 650.967.3394

FAX 650.934.2950

1
Design Firm
Free-Range Chicken Ranch
Art Director
Kelli Christman
Designer
Kelli Christman
Illustrator
Sandy Gin
Client
Sequence
Software/Hardware
QuarkXpress, Adobe Illustrator
Paper/Materials
Starwhite Vicksburg 130 lb.
Cover
Printing
Offset, PMS inks

2
Design Firm
Sb Design - Brazil
Designer
Ricardo Bastos
Client
Le Bistrot Restaurant
Software/Hardware
Corel Draw, PC
Paper/Materials
Esse, Dark Tan (216glm2) Texture
Printing
Offset

Fernando Marins

Fernando Gomes, 58 • 90.510-010 • Porto Alegre • RS
Fone: (051) 346.3812

2

ULRICH R. WALL
General Manager

Tel 212.320.2940
Fax 212.320.2941
E-mail uwalltime@sprynet.com

224 West 49th Street New York, NY 10019

1

1

Design Firm
 Mirko Ilić Corp.
Art Director
 Mirko Ilić
Designer
 Mirko Ilić
Client
 The Time Hotel

2

Design Firm
 Sibley Peteet Design
Designers
 Donna Aldridge, Tom Kirsch,
 David Beck
Client
 AGI Klearfold
Software/Hardware
 Adobe Illustrator, Macintosh
Printing
 Monarch Press

3

Design Firm
 Sackett Design Associates
Art Director
 Mark Sackett
Designers
 George White, James Sakamoto,
 Wendy Wood
Photographer
 Stock
Client
 communities.com
Software/Hardware
 QuarkXpress, Adobe Illustrator,
 Adobe Photoshop
Paper/Materials
 100 lb. Bright White
 Vellum Cover
Printing
 Forman Lithograph

www.communities.com
www.thepalace.com
www.onlive.com

CAROLYN E. VAN NESS
EXECUTIVE ADMINISTRATOR & OFFICE MANAGER
DIRECT 408.342.9506

communities.

10101 NORTH DE ANZA BLVD · SUITE 100
CUPERTINO, CALIFORNIA · 95014.2264
PHONE 408.342.9500 · FAX 408.777.9200

carolyn@communities.com

3

IMPAC™
G R O U P

AGI
KLEARFOLD

RICHARD BLOCK
President & CEO

1776 BROADWAY
NEW YORK, NY 10019-2002
TEL 212.489.0973 Ext. 7110
FAX 212.489.0255

rblock@impacgroup.com

2

4
Design Firm
 Free-Range Chicken Ranch
Art Director
 Kelli Christman
Designer
 Kelli Christman
Client
 web•ex by ActiveTouch
Software/Hardware
 QuarkXpress, Adobe Illustrator
Paper/Materials
 Starwhite Vicksburg 130 lb.
Printing
 Offset, Special Inks

Charles J. Orlando
**DIRECTOR OF MARKETING
COMMUNICATIONS**

5225 Betsy Ross Drive
Santa Clara, California 95054
408.980.5200 x2145
fax: 408.980.5280
charles@webex.com
www.activetouch.com

we've got to start
meeting like this™

www.webex.com

4

zoë

Pan-Asian Café
and catering company

4753 McPherson
Saint Louis, MO 63108
Phone: 314/361-0013 Fax: 361-4041

1
Design Firm
 The Puckett Group
Art Director
 Candy Freund
Designer
 Candy Freund
Illustrator
 Candy Freund
Client
 Zoë Pan-Asian Café
Software/Hardware
 QuarkXpress, Adob
Paper/Materials
 8o lb. Strathmore
 White Wove Cover
Printing
 Offset, 4 PMS Colc
 Printer: Reprox

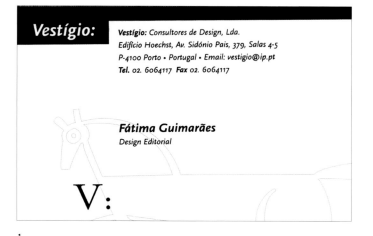

1

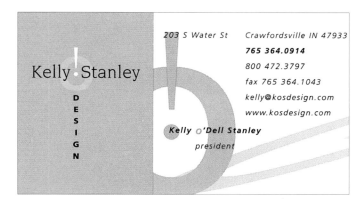

2

3

1
Design Firm
Vestígio
Art Director
Emanuel Barbosa
Designer
Emanuel Barbosa
Client
Self-promotion
Software/Hardware
Freehand, Macintosh
Paper/Materials
Favini Milho
Printing
1 Color

2
Design Firm
Kelly O. Stanley Design
Art Director
Kelly O'Dell Stanley
Client
Self-promotion
Software/Hsrdware
Freehand, QuarkXpress,
Macintosh
Paper/Materials
Esse Smooth White
Prinitng
2 Color

3
Design Firm
Tim Kenney Design Partners
Art Director
Tim Kenney
Designer
Monica Banko
Client
Global Cable Consulting
Group
Software/Hardware
Freehand, QuarkXpress,
Macintosh
Paper/Materials
Gilbert Neutech Ultra White
Wove
Printing
London Litho

kathie swift, cfe marketing director

iowa state fair - statehouse - 400 east 14th street

des moines, iowa 50319-0198

515/262 - 3111 ext. 204 fax

http://www.i

e-mail kathie@iowastatefair.org

Design Firm
 Sayles Graphic Design
Art Director
 John Sayles
Designer
 John Sayles
Illustrator
 John Sayles
Client
 1998 Iowa State Fair
Software/Hardware
 Adobe Illustrator 7.0
Paper/Materials
 Cougar 80 lb. Smooth
 Cover
Printing
 Artcraft

Design Firm
Sayles Graphic Design
Art Director
John Sayles
Designer
John Sayles
Illustrator
John Sayles
Client
1999 Iowa State Fair
Software/Hardware
Adobe Illustrator 7.0
Paper/Materials
Hammermill Accent Vellum
Opaque 80 lb. Cover
Printing
Pella Printing

1

1

Design Firm
Hornall Anderson Design Works

Art Director
Jack Anderson

Designers
Jack Anderson, David Bates

Illustrator
David Bates

Client
Self-promotion

Paper/Materials
French Durotone, Packaging
Gray Liner 80 lb. C

2

Design Firm
Second Floor

Art Director
Warren Welter

Designer
Warren Welter

Illustrator
Lori Powell

Client
5th Avenue Suites Hotel

Software
QuarkXPress, Adobe Illustrator,
Macintosh

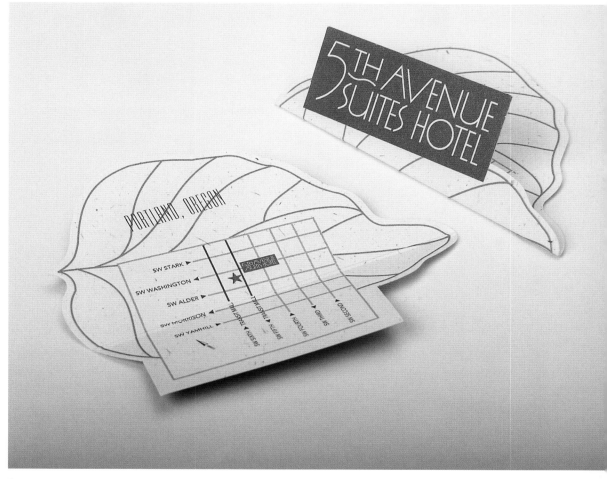

2

Estudio Hache
Diseño Gráfico y Multimedia

Vedia 1682 - 3º
1429 Buenos Aires
República Argentina

4704-0202
4446-1393

info@estudiohache.com
www.estudiohache.com

Laura Lazzeretti

Marcelo Varela

Design Firm
Estudio Hache S.A.
Designers
Laura Lazzeretti,
Marcelo Varela
Photographers
Marcelo Varela,
Laura Lazzeretti
Client
Self-promotion
Software/Hardware
Adobe Photoshop, Adobe
Illustrator, Macintosh
Paper/Materials
4 Color Printing, Water Based
Varnish on 235 g Coated Paper
Printing
Neuhaus S.A.

Lynn Ridenour
Director of
Corporate
Communications
425.519.9313
lynnr@onyx.com

310-120th Ave NE
Bellevue, WA 98005
(T) 425.451.8060
(F) 425.519.4002
www.onyx.com

Design Firm
Hornall Anderson Design Works
Art Director
John Hornall
Designers
Debra McCloskey,
Holly Finlayson,
Jana Wilson Esser
Client
Onyx Software Corporation
Software/Hardware
Freehand, Macintosh

Design Firm
 Ricardo Mealha Atelier
 Design Estrategico
Art Director
 Ricardo Mealha
Designer
 Leonel Duarte
Client
 Luis De Barros
Software/Hardware
 Freehand 8.0
Paper/Materials
 Martin Paper
Printing
 Ma Artes Graficas

Porto

Póvoa

Braga

Lisboa

Administração / Direcção
av. Mouzinho de Albuquerque,
n.º 184 R/c
4490 Póvoa de Varzim

tel.: 351 - 52 - 298 0 80
fax: 351 - 52 - 298 0 89

Armazém rua Silveira Campos,
n.º 38, Arm. a — Aver-o-Mar,
4490 Póvoa de Varzim

tel.: 351 - 52 - 61 45 56
fax: 351 - 52 - 61 89 71

Shopping Cidade do Porto
tel.: 02 - 600 91 70

Pr. Galiza - Porto
tel.: 02 - 600 95 05

Viacatarina Shopping - Porto
tel.: 02 - 200 36 73

Arrábida Shopping - Porto
tel.: 02 - 374 54 53

Norte Shopping - Porto
tel.: 02 - 955 98 86

Póvoa de Varzim
tel.: 052 - 298 0 81

Braga Shopping
tel.: 053 - 267 0 61

Braga Parque
tel.: 053 - 257 9 31

Centro Vasco da Gama
Lisboa
tel.: 01 - 895 13 98

Design Firm
Ricardo Mealha Atelier
Design Estrategico
Art Director
Ricardo Mealha
Designer
Ana Margarida Gunha
Client
Prof
Software/Hardware
Freehand 8.0
Paper/Materials
Martin Paper
Printing
M2 Artes Graficas

Design Firm
be
Art Director
Eric Read
Designer
Eric Read
Client
inhaus industries
Software/Hardware
Adobe Illustrator,
Macintosh

1

2

1
Design Firm
 Visual Marketing Associates
Art Directors
 Jason Selke, Ken Botts
Designer
 Jason Selke
Illustrator
 Jason Selke
Client
 Future of Diabetics, Inc.
Software/Hardware
 Freehand 8.0, Photoshop 5.0
Paper/Materials
 Proterra
Printing
 Thomas Graphics

2
Design Firm
 Girvin
Art Director
 Gretchen Cook
Designer
 Sam Knight
Illustrator
 Gretchen Cook
Client
 Living by Design
Software/Hardware
 Freehand, Adobe Illustrator 8.0,
 Macintosh
Paper/Materials
 Strathmore Renewal
 Smooth, Calm
Printing
 2 Color Offset

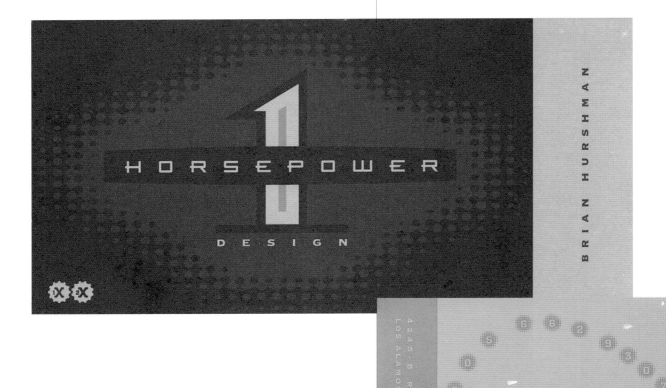

Design Firm
 1 Horsepower Design
Designer
 Brian Hurshman
Client
 Self-promotion
Software/Hardware
 Macintosh

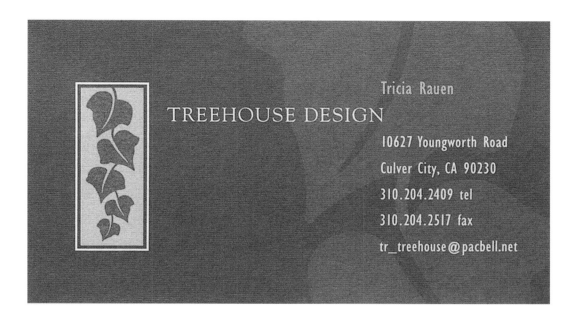

Treehouse Design
Tricia Rauen
TREEHOUSE DESIGN
10627 Youngworth Road
Culver City, CA 90230
310.204.2409 tel
310.204.2517 fax
tr_treehouse@pacbell.net

Design Firm
 Treehouse Design
Art Director
 Tricia Rauen
Designer
 Tricia Rauen
Illustrator
 Tricia Rauen
Client
 Self-promotion
Software/Hardware
 Adobe Illustrator
Paper/Materials
 Classic Crest Duplex Cover,
 (Saw Grass, Natural White)
Printing
 Typecraft, Inc.

SPIN PRODUCTIONS TORONTO/ATLANTA WWW.SPINPRO.COM
620 KING ST WEST TORONTO ONTARIO CANADA M5V IM6
TELEPHONE 416 504 8333 FACSIMILE 416 504 3876

CONNIE DERCHO
SENIOR PRODUCER
connie@spinpro.com

SPIN PRODUCTIONS

SPIN PRODUCTIONS TORONTO/ATLANTA WWW.SPINPRO.COM
620 KING ST WEST TORONTO ONTARIO CANADA M5V IM6
TELEPHONE 416 504 8333 FACSIMILE 416 504 3876

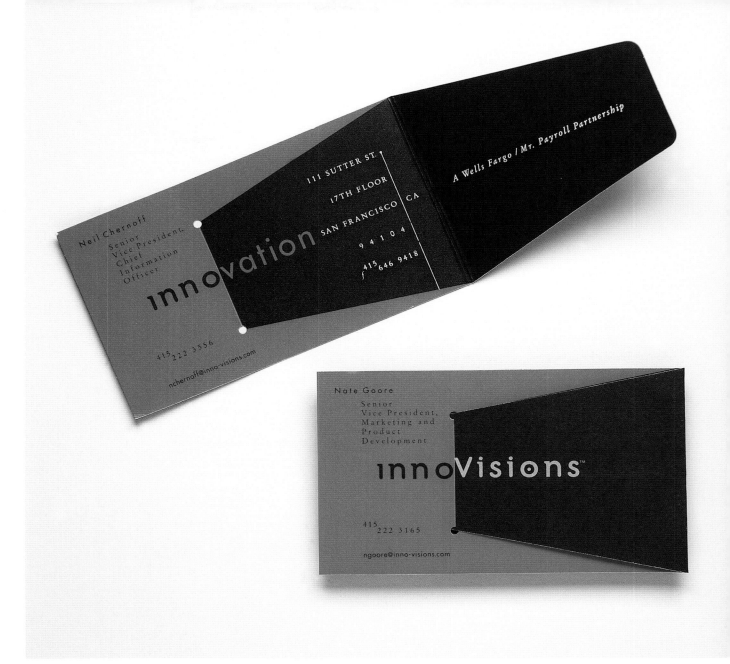

2

1
Design Firm
 Spin Productions
Art Director
 Spin Productions
Designer
 Spin Productions
Illustrator
 Spin Productions
Photographer
 Spin Productions
Client
 Self-promotion
Software/Hardware
 QuarkXpress, Adobe Photoshop,
 Macintosh
Printing
 CJ Graphics

2
Design Firm
 Hornall Anderson
 Design Works
Art Director
 Jack Anderson
Designers
 Jack Anderson, Kathy Saito,
 Alan Copeland
Client
 Wells Fargo "innoVisions"
Software/Hardware
 Freehand, Macintosh
Paper/Materials
 Mohawk Superfine,
 Bright White

**TOWN
HOUSE**
**PROPIEDADES
Y SERVICIOS**

AGUILAR 2436
1426 BUENOS AIRES
TELEFAX: 4780-2200
e-mail: townhouse
@interlink.com.ar

Arq. Abel Trybiarz
Director

**WOHLGEMUTH
TAUBER SA**
E M P R E S A
CONSTRUCTORA

AGUILAR 2436
1426 BUENOS AIRES
TEL.: 4780-2200
e-mail: townhouse
@interlink.com.ar

Daniel Wohlgemuth
Presidente

GRUPO TOWN HOUSE

**WAISMAN
TRYBIARZ**
ARQUITECTURA
POR OBJETIVOS

**WOHLGEMUTH
TAUBER S.A.**
E M P R E S A
CONSTRUCTORA

TOWN HOUSE
PROPIEDADES
Y SERVICIOS

Arq. Gerardo Waisman

AGUILAR 2436
1426 BUENOS AIRES
TEL: 4780-2200
e-mail: townhouse
@interlink.com.ar

1

**WAISMAN
TRYBIARZ**
**ARQUITECTURA
POR OBJETIVOS**

AGUILAR 2436
1426 BUENOS AIRES
TEL.: 4780-2200
e-mail: townhouse
@interlink.com.ar

Arq. Abel Trybiarz

1
Design Firm
 Estudio Hache S.A.
Designers
 Laura Lazzeretti,
 Marcelo Varela
Client
 Grupo Town House
Software/Hardware
 Adobe Illustrator, Macintosh
Paper/Materials
 Oreplus 240g
Printing
 Bahía Graf SRL

2
Design Firm
 Studio Boot
Art Directors
 Petra Janssen,
 Edwin Vollebergh
Designers
 Petra Janssen,
 Edwin Vollebergh
Client
 Self-promotion
Paper/Materials
 MC on 3mm Grey Board
Printing
 Full Color and Laminate

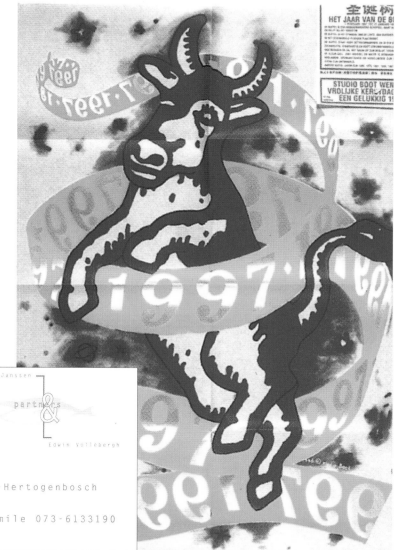

2

Design Firm
 Voice Design
Art Director
 Clifford Cheng
Designer
 Clifford Cheng
Client
 Self-promotion
Software/Hardware
 Adobe Photoshop,
 QuarkXpress, Macintosh
Printing
 Offset, 2 Color

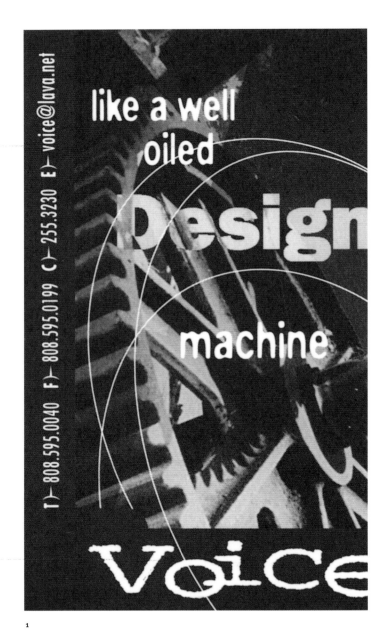

1

1

2

1
Design Firm
Cisneros Design
Designer
Eric Griego
Client
Timberline Inc.
Software/Hardware
Macintosh
Paper/Materials
Evergreen
Printing
Aspen Printing, Albuquerque

2
Design Firm
Geographics
Designer
Tanya Doell
Client
Coyotes Deli & Grill
Software/Hardware
Adobe Illustrator, Adobe
Photoshop, QuarkXpress
Paper/Materials
Genesis Husk
Printing
3 Spot

Job✓rder™
maximizing business productivity

VICTOR SIEGLE
PRESIDENT

Management Software Inc.
17 Main Street, Suite 313
Cortland, New York 13045
e-mail victor_siegle@joborder.com
Phone 607.**756.4150**
Facsimile 607.756.5550

Design Firm
Big Eye Creative
Art Director
Perry Chua
Designers
Perry Chua, Nancy Yeasting
Client
Management Software, Inc.
Software/Hardware
Adobe Illustrator,
Adobe Photoshop

GROUND

zerø

ROB RINDOS

www.gzdesign.com

T 719.955.1100 ext:415
F 719.955.1104
Toll Free: 877.363.8449
CORPORATE OFFICE:
2845 JANITELL ROAD COLORADO SPRINGS COLORADO 80906

GROUND

ROB RINDOS

rrindos@gzdesign.com

www.gzdesign.com

T 614.764.0227
F 614.764.3796

297 TREE HAVEN NORTH POWELL OHIO 43065

1

Design

Ramona Hutko

4712 South Chelsea Lane 301
Bethesda Maryland 20814 656 2763

2

1
Design Firm
 Hornall Anderson Design Works
Art Director
 Jack Anderson
Designers
 Kathy Saito, Julie Lock, Ed Lee,
 Heidi Favour, Virginia Le
Client
 Ground Zero
Software/Hardware
 Freehand, Macintosh

2
Design Firm
 Ramona Hutko Design
Art Director
 Ramona Hutko
Designer
 Ramona Hutko
Client
 Self-promotion
Software/Hardware
 QuarkXpress
Paper/Materials
 Mohawk Superfine Cover

Design Firm
 Skarsgard Design
Designer
 Susan Skarsgard
Hand-lettering
 Susan Skarsgard
Client
 Ann Arbor Street Art Fair
Printing
 Offset 4 Color

Design Firm
 Visser Bay Anders Toscani
Art Director
 Thea Bakker
Designer
 Thea Bakker
Client
 Qi At Vbat
Paper/Materials
 Royal Quadrant High White
 250 gr.

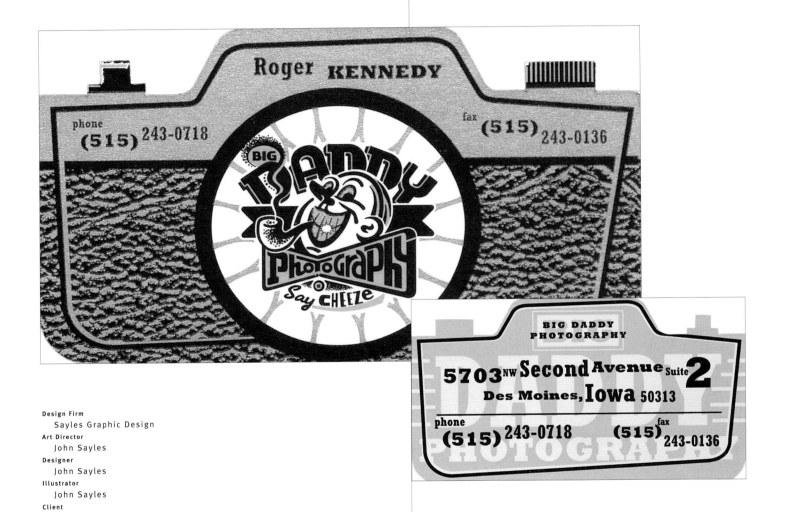

Design Firm
 Sayles Graphic Design
Art Director
 John Sayles
Designer
 John Sayles
Illustrator
 John Sayles
Client
 Big Daddy Photography
Software/Hardware
 Adobe Illustrator 7.0
Paper/Materials
 Classic Crest 110 lb. Cover:
 Natural White
Printing
 Artcraft

Design Firm
 Sayles Graphic Design
Art Director
 John Sayles
Designer
 John Sayles
Illustrator
 John Sayles
Client
 Barrick Roofing
Software/Hardware
 Adobe Illustrator 7.0
Paper/Materials
 Classic Crest 100 lb. Cover,
 Bright White
Printing
 Artcraft

IE DESIGN

[i]e design

13039 VENTURA BLVD
STUDIO CITY, CA 91604
TEL 818 907 8000
FAX 818 907 8830
EMAIL mail@iedesign.net

COREY BAIM
PRINCIPAL/BUSINESS

Design Firm
[i]e design
Designer
Marcie Carson
Photographer
Kevin Merrill
Client
Self-promotion
Software/Hardware
Adobe Photoshop,
QuarkXpress, Macintosh
Paper/Materials
Esse Paper, 4 Color Tip-in
Printing
Silver PMS and 4 Color Process

GeoForm Products, LLC
3803 E. 75th Terrace
P.O. Box 320176
Kansas City, MO
64132

Cell: 816-916-6865

Phone: 816-333-6967

Fax: 816-333-6922

Email:
GBrattrud@geoformproducts.com

GEOFORM
PRODUCTS, LLC

Gale Brattrud
President

*Manufacturer of Ashton Bay
Bath & Lighting Accessories*

1

1
Design Firm
 Love Packaging Group
Art Director
 Chris West
Designer
 Lorna West
Illustrator
 Lorna West
Client
 Geoform Products, L.L.C.
Software/Hardware
 Freehand 8.0
Paper/Materials
 White Strathmore 80 lb.
Printing
 Litho Press

2
Design Firm
 Guidance Solutions
Art Director
 Rob Bynder
Designer
 Brad Benjamin
Client
 Self-promotion

2

Design Firm
 Sibley Peteet Design
Designer
 Tom Hough
Illustrator
 Tom Hough
Client
 Baker Bros
Software/Hardware
 Adobe Illustrator, Macintosh
Printing
 Knight Graphics

KENNETH F. REIMER
CHAIRMAN

3712 MCFARLIN BLVD.

DALLAS, TEXAS 75205

214.520.3882

FAX 214.520.3894

2
Design Firm
Gregory Group
Art Director
Jon Gregory
Client
Bella Vista Townhouse
Association

3
Design Firm
Gregory Group
Art Director
Jon Gregory
Client
Sutherland Teak Furnishings
Software/Hardware
QuarkXpress, Adobe Illustrator,
Adobe Photoshop, Macintosh

1
Design Firm
Gregory Group
Art Director
Jon Gregory
Client
The Fitting Room

Clothing Alterations

Custom Designs

Home Accessories

Gifts

THE FITTING ROOM
BY BEA HARPER

4108 Lomo Alto at Lemmon

Dallas, TX 75219

Phone/Fax

214. 520.3600

1

BELLA VISTA
Townhouse Association

JACK WISNER, GENERAL MANAGER

P.O. BOX 5301, BELLA VISTA, AR 72714-0301, (501) 855-9328

2

TIM RYAN
NATIONAL SALES MANAGER

SUTHERLAND
TEAK FURNISHINGS

3229 HALIFAX, DALLAS, TEXAS 75247
214. 638.4161, FAX 214. 638.5004
1.800.717.TEAK (8325)

3

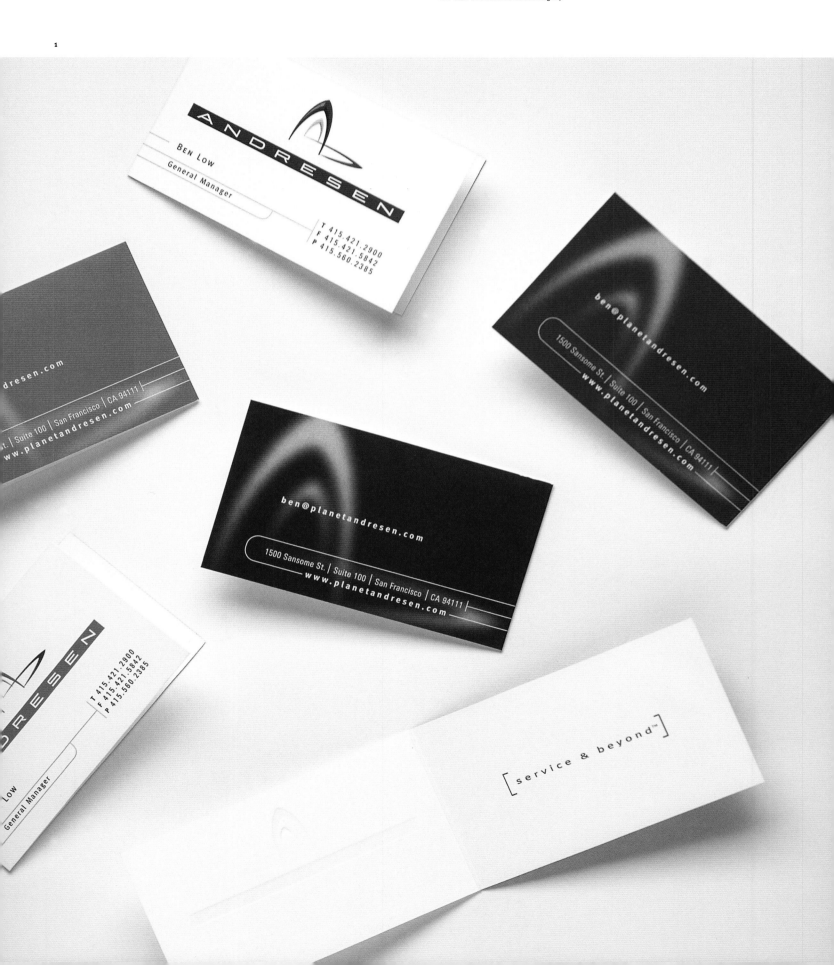

1
Design Firm
 be
Art Director
 Will Burke
Designer
 Eric Read
Client
 Andresen
Printing
 Andresen

2
Design Firm
 Atelier Tadeusz Piechura
Art Director
 Tadeusz Piechura
Designer
 Tadeusz Piechura
Client
 Self-promotion
Software/Hardware
 Corel 7
Printing
 Offset

2

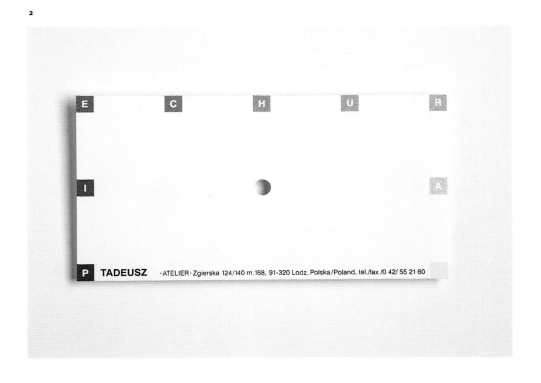

Directory

Afterhours: pt Grafika Estetika Atria
Jalan Merpati Raya 45
Jakarta 12870
INDONESIA
brahm@afterhours.co.id

Aloha Printing
880 W. 19th Street
Costa Mesa, CA 92627

Atelier Tadeusz Piechura
Zgierska 124/140, M.168
91-320 Lodz
POLAND

be
1323 4th Street
San Rafael, CA 94901
will.burke@beplanet.com

Becker Design
225 East St. Paul Avenue
Suite 300
Milwaukee, WI 53202
beckerdsgn@aol.com

Belyea
1809 7th Avenue, #1250
Seattle, WA 98101
mandy@belyea.com

**Bettina Huchtemann
Art-Direction & Design**
Schröderstiftstrasse 28
20146 Hamburg
GERMANY
bhuchtemann@real-net.de

Big Eye Creative, Inc.
101-1300 Richards Street Vancouver
British Columbia V6B 3G6
CANADA
mecium@bigeyecreative.com

Blue Suede Creative
2525 Ontario Street
Vancouver
CANADA
bsuede@istar.ca

Bruce Yelaska Design
1546 Grant Avenue
San Francisco, CA 94133
bruceyelaska@yelaskadesign.com

Cairnes
21 Station Road
Barnes LONDON SW13 0LJ
ENGLAND
tony.sharman@cairnesdesign.co.uk

Case
St. Annastraat 1g Breda
THE NETHERLANDS
kwcase@knoware.nl

Castenfors & Co.
Roslagsgatan 34, SE 11355
Stockholm
SWEDEN
jonas@castenfors.com

Cincodemayo Design
5823 Northgate, PMB668
5 de Mayo Pte. 1058
Monterrey, N.L.
MEXICO 64000
malanis@mail.cmact.com

Cisneros Design
1751-A Old Pecos Trail
Santa Fe, NM 87505
cisneros@rt66.com

**Cooper-Hewitt,
National Design Museum**
2 East 91st Street
New York, NY 10128
manuean@ch.si.edu

Crabtree Hall
70 Crabtree Lane
LONDON SW6 6LT
ENGLAND
crabtreehall.com

Creative Company
3276 Commercial Street SE
Salem, OR 97302
mikeyp@creativeco.com

D Zone Studio, Inc.
273 W. 7th Street
San Pedro, CA
jyule@dzsinc.com

Dean Johnson Design
646 Massachusetts Avenue
Indianapolis, IN 46204
Dean7jd@aol.com

Dennis Irwin Illustration
1251 College Avenue
Palo Alto, CA 94306
dei2465@fhda.edu

**Desgrippes Gobé &
Associates-Brussels**
Rue des Mimosas 44
B-1030 Brussels
BELGIUM
desgrippes.gobe@skynet.be

Design Center
15119 Minnetonka Boulevard
Minnetonka, MN 55345
dc@design-center.com

DMX Design
838 Broadway, 6th Floor
New York, NY 10003
petrie@dmxdesign.com

DoX Industries
1337 Stillwood Chase
Atlanta, GA 30306
kannex@doxindustries.com

Elizabeth Resnick Design
126 Payson Road
Chestnut Hill, MA 82467
elizres@aol.com

Erwin Zinger Graphic Design
Bunnemaheerd 68, 9737 Re
Groningen
HOLLAND
erwin_zinger@hotmail.com

Esfera Design
R Barão Santa Marta, 519/04372-100
Sao Paulo
BRAZIL
esferadg@uol.com.br

Estudio Hache S.A.
Vedia 1682 3rd floor
1429 Buenos Aires
ARGENTINA
info@estudiohache.com

Fifth Street Design
1250 Addison Street
Studio 4
Berkeley, CA 94702
info@fifthstreet.com

Form Studio
718 W. Howe Street
Seattle, WA 98119
info@formstudio.com

400 Communications Ltd.
20 The Circle
Queen Elizabeth Street
LONDON SE1 2JE
ENGLAND
peter_dawson@400.co.uk

Free-Range Chicken Ranch
330 A East Campbell Avenue
Campbell, CA 95008
frcr@earthlink.net

gag
Ludolf-behl-str.73-77
D-68767 Mannheim
GERMANY
info@gag-ma.de

Geographics
P.O. Box 2560
Number 1-200 Hawk Avenue
Banff, Alberta, CANADA TOL OCO
tanya@geodesign.com

Girvin
1601 2nd Avenue, 5th Floor
Seattle, WA 98101
info@girvin.com

graphische formgebung
Pulverstr. 25 D-44869 Bochum
GERMANY
herbert.rohsiepe@gelson.net

Graven Images Ltd.
83a Candleriggs, Glasgow
SCOTLAND
anon@graven.compulink.co.uk

Gregory Group
1925 Cedar Springs Road
Suite 206
Dallas, TX 75201
craig@gregorygroup.com

Greteman Group
1425 E. Douglas
Wichita, KS 67211
sgreteman@gretemangroup.com

Guidance Solutions
4134 Del Rey Avenue
Marina del Rey, CA 90292-5604

H3/Muse
490 Ridgecrest Ave.
Los Alamos, NM 87544

Harris Design
9 Marion Avenue
Andover, MA 01810
maddad@mediaone.net

Heads Inc.
176 Thompson, #2D
New York, NY 10012
soso@bway.net

**Herman Miller Marketing
Communications Dept.**
855 E. Main MS0162
Zeeland, MI 49464
brian_edlefson@hermanmiller.com

Hornall Anderson Design Works
1008 Western Avenue
Suite 600
Seattle, WA 98104
c_arbini@hadw.com

[i]e design
13039 Ventura Boulevard
Studio City, CA 91604
mail@iedesign.net

Inkwell Publishing Co., Inc.
10 San Pablo Street
Bo.Kapitolyo
Pasig City
PHILIPPINES 1603
inkwell@mnl.sequel.net

Inox Design
Via Terraggio 11
20123 Milano
ITALY
inox@comm2000.it

IVADOME
1111 Park Avenue, #416
Baltimore, MD 21201
info@ivadome.com

Izak Podgornik
Jamova c. 50
1000 Ljubljana
SLOVENIJA
izak.podgornik@siol.net

J. Gail Bean, Graphic Design
613 Hardy Circle
Dallas, GA 30157
gailbean@mindspring.com

Jeanne Goodman
1334 Botetourt Gardens
Norfolk, VA 23517-2204
jgood51@aol.com

José J. Dias da S. Junior
Rua Nilza Medeiros Martins,
275/103
05628-010 Sao Paulo
BRAZIL
jjjunior@mandic.com.br

Josh Klenert
106 E. 19th Street, 8th Floor
New York, NY 10003-2126
jaykayo1@aol.com

Joy Price
8610 Southwestern, #404
Dallas, TX 75206
joy@spddallas.com

Kan &Lau Design Consultants
28/F Great Smart Tower
830 Wanchai Road
HONG KONG
kan@kanandlau.com

Kelly O. Stanley Design
203 S. Water St.
Crawfordsville, IN 47933
kelly@kosdesign.com

Langer Design
Plusstrasse 86
50823 Köln
GERMANY

LF Banks & Associates
834 Chestnut Street
Suite 425
Philadelphia, PA 19107
banks@lfbanks.com

Love Packaging Group
410 E. 37th Street North/PL 2
Wichita, KS 67219
dcommer@lovebox.com

Manhattan Transfer
545 Fifth Avenue
New York, NY 10017
greg@mte.com

Martin Lemelman Illustration
1286 Country Club Road
Allentown, PA 18106-9641
martart@erols.com

Matite Giovanotte
Via Degli Orgogliosi 47100 Forli
ITALY
marimg@tim.it

MD Studio
600 W. 174th Street, #33
New York, NY 10033-7902
mdomingu@wiley.com

Media Bridge
1545 Wilcox Avenue #B5
Los Angeles, CA 90028-7316
gproven942@aol.com

Michael Kimmerle - Art Direction + Design
Ostendstr.106.70788 Stuttgart
GERMANY
mi@kimmerle.de

Mirko Iliæ Corp.
207 East 32nd Street
New York, NY 10016

Natto Maki
30 Ramona Avenue #2
San Francisco, CA 94103
mike@bartalos.com

Nesnadny & Schwartz
10803 Magnolia Drive
Cleveland, OH 44106

Nichols & Zwiebel
One Yesler Way
Seattle, WA 98104
nandz@compuserve.com

Niehinger & Rohsiepe
Pulverstr. 25
D-44869 Bochum,
GERMANY
herbert.rohsiepe@gelson.net

1 horsepower design
4245-b Ridgeway
Los Alamos, NM 87544

O₂ Design
Tanner Place
54-58 Tanner St.
London SE1 3HP
ENGLAND

Opera Grafisch Ontwerpers
Baronielaan 78
NL-4818 RC Breda
THE NETHERLANDS
operath@knoware.nl

Petter Frostell Graphic Design
Roslagsgatan 34
11355 Stockholm
SWEDEN
petter.frostell@telia.com

Pfeiffer plus Company
1910 Pine Street
Suite 515
St. Louis, MO 63103
creative@pfeifferplus.com

PXL8R Visual Communications
P.O. Box 7678
Van Nuys, CA 91409
info@pxl8r.com

R & M Associati Grafici
Traversa Del Pescatore 3
80053 Castellammare Di Stabia
ITALIA
info@rmassociati.com

Ramona Hutko Design
4712 South Chelsea Lane
Bethesda, Maryland 20814

**Ricardo Mealha
Atelier Design Estrategico**
Av. Eno Duarte Dachelo
Torre2
Piso 2 Sazas 9 & 10
PORTUGAL

Ringo W.K. Hui
Rm 404, Wo Hui House
Wo Ming Court
Tseung Kwan o
HONG KONG

S & S Design
Francisco de Toledo 241La
Virreyna
Lima 33
PERU
sanfarmo@comercio.com.pe

Sackett Design Associates
2103 Scott Street
San Francisco, CA 94115
marksackett@sackettdesign.com

Sagmeister Inc.
222 West 14th Street
New York, NY 10011
ssagmeiste@aol.com

Sayles Graphic Design
3701 Beaver Avenue
Des Moines, IA 50310

Sb design
Rua Furriel Luiz A. Vargas
380/203
90470-130 Porto Alegre RS
Brazil
sbdesign@myway.com.br

Scraps arternative designs
266u-268 Somerset Street
No. Plainfield, NJ 07060

Second Floor
443 Folsom Street
San Francisco, CA 94105
design@secondfloor.com

Sibley Peteet Design
3232 McKinney, #1200
Dallas, TX 75204
rhonda@spddallas.com

Skarsgard Design
807 Hutchins Avenue
Ann Arbor, MI 48103
skarsgard@bigfoot.com

Spectrum Graphics Studio
2860 Carpenter Road
Suite 100B
Ann Arbor, MI 48108

Spin Productions
620 King Street West
Toronto, Ontario
CANADA
M5V1M6
norm@spinpro.com

Stang
Gedempte Zalmhaven 835
3011 BT Rotterdam
HOLLAND
stang@ipr.nl

Stewart Monderer Design, Inc.
10 Thacher Street
Boston, MA 02113
sm@monderer.com

Studio Boot
Brede Haven
8A's-Hertogenbosch
THE NETHERLANDS

"That's Nice" l.l.c.
1 Consulate Drive, #3N
Tuckahoe, NY 10707-2426

The Hive Design Studio
10 Jackson Street, #204
Los Gatos, CA 95032
amyb13@aol.com

The Puckett Group
7521 Buckingham Drive, #2W
St. Louis, MO 63105
candy_freund@simmons-
durham.com

The Riordon Design Group
131 George Street
Oakville, ON L6J 3B9
group@riordondesign.com

The Weller Institute for the Cure of Design, Inc.
P.O. Box 518
Oakley, UT 84055
chachaw@allwest.net

Tim Kenney Design Partners
3 Bethesda Metro Center
Suite 630
Bethesda, MD 20814
julie@tkdp.com

Total Creative, Inc.
8360 Melrose Avenue
3rd Floor
Los Angeles, CA 90069
pmcguirk@totalcreativeinc.com

Treehouse Design
10627 Youngworth Road
Culver City, CA 90230
tr_treehouse@pacbell.net

Troller Associates
12 Harbor Lane
Rye, NY 10580

twenty2product
440 Davis Court
Apt. 509
San Francisco, CA 94111-2412
terry@twenty2.com

Urbangraphic
3165 Kershawn Place
Escondido, CA 92029-6626
urbangraph@aol.com

Vestígio
Rua Chaby Pinheiro, 191-2°
P-4460-278
Sra. da Hora
PORTUGAL
info@vestigio.com

Via Vermeulen
William Boothlaan 4
Rotterdam
THE NETHERLANDS
viarick@ipr.nl

Visser Bay Anders Toscani
Assumburg 152, Postbus
P.O. Box 71116
1008 BC AMSTERDAM
HOLLAND
oracle@vbat.nl

Visual Marketing Associates
322 S. Patterson Boulevard
Dayton, OH 45402
info@vmai.com

Voice Design
1385 Alewa Drive
Honolulu, HI 96817
voice@lava.net

Wallace/Church
330 E. 48th Street
New York, NY 10017
wendy@wallacechurch.com

Zeigler Associates
107 E. Cary Street
Richmond, VA 23219
zeiglera@erols.com

Zeroart Studio
P.O. Bos 71466, Kowloon
Central Post Office
HONG KONG
zeroart@netvigator.com

About the Author

Jeannet Leendertse was born and studied graphic design in the Netherlands. Her work has appeared in *Print*, the AIGA 50 Books Show, and has been awarded by the Association of American Publishers and in The Leipzig International Book Competition. She currently designs freelance and lives in Medfield, Massachusetts.